EYE CONTACT

SOCIAL NETWORKING
{Face-to-Face}
WITH A CAMERA

Photographs by
Max James Fallon

CAMERON + COMPANY

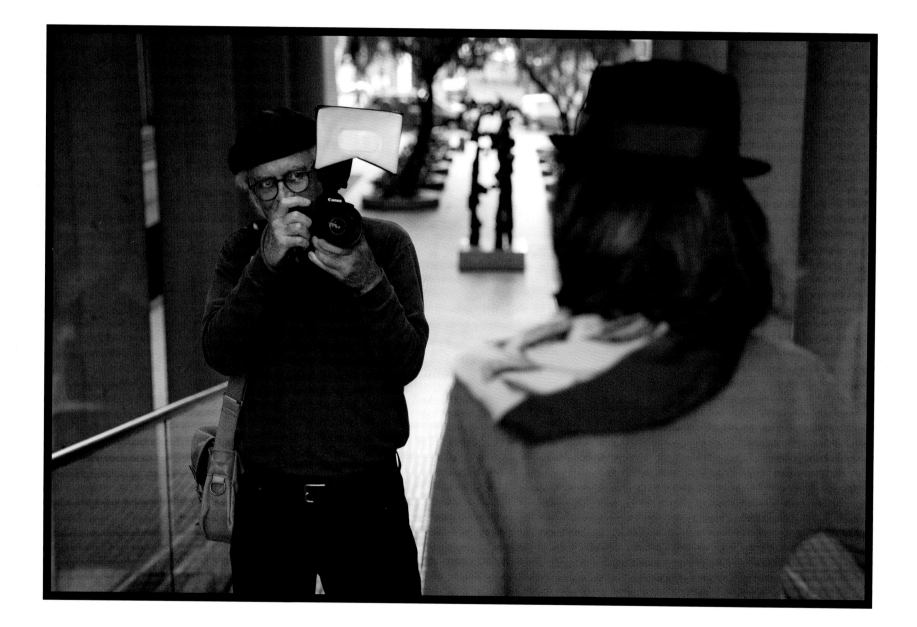

The Author ∫ Photo by Eric Poelzl

CONTENTS

INTRODUCTION

Since you're perusing this book, you're likely to be interested in photography, or perhaps you *are* a professional photographer, or, lucky you, someone just gave you this book as a gift, thinking you *might* be interested in photography. So what's it about, you ask? As you flip through the pages, you'll notice that the subjects are staring back at you, all of them. That's because I believe in getting close, interacting face to face, in a context that communicates to the lens something real about their lives and culture, and that dialogue is most apparent when the subject has made eye contact with me, and thus to you, the viewer, in a language that's universal. I try to communicate to them that I'm genuinely intrigued. I do this by asking for a moment of intimacy: a photograph. As a photographer, I long ago realized that I had a strong desire to share what I've seen and experienced as I explored the world with a camera: having file drawers full of prints no one was ever going to see didn't appeal to me—thus, this book. Put quite simply, I hope my photographs inspire you to use your camera to really *engage* with your fellow world citizens, seeing them from a very personal perspective, then coming away with a strong, compelling photograph of that meeting—the perfect souvenir!

The camera is the ideal instrument for that engagement. To photograph people with their consent and involvement requires us to request rather than dictate, to interpret instead of define, to participate as well as observe. It requires no language skills. Its function and purpose is understood by all. I urge you to get out there and approach someone who interests you, someone with whom you feel, for some reason, a shared, common humanity. It's as simple as asking, "Excuse me, do you mind if I take your picture?" I admit, it may not be the most brilliant opening line, but that simple question usually starts a conversation, that often leads to more talk about ourselves, and the situation/location we're in. If they agree to be photographed, I work with them to produce an image that, hopefully, will say something important about them, and possibly, about their culture. And if language is an issue, you need to find a quick way to establish a certain level of trust with your subject: creative sign language is a good start, a sincere smile while making eye contact, maybe show a sample photograph to let them know what you have in mind.

You may think the photographs in this book appear to be unrelated images, a nonlinear collection of portraits, a reflection of my interests and travels. It's true they don't follow a

straightforward narrative, but after viewing them, I think you may see them more as a photo essay: my subjective take on people who have affected and moved me in some way. *In addition to my notes related to the portraits, you'll also find personal statements from my guest contributors on how they interact with people they're drawn to: how they photograph them, always looking for that evocative moment; or just anecdotes that relate to the book's theme.*

Life should be about new experiences. If used seriously, the camera grants you access to meet people wherever you find yourself, whether on the other side of the globe or in your own community. It's always a delight to meet and photograph an interesting stranger, especially if you've gone outside your normal comfort zone. Take a risk . . . it may be a bit scary at first, but far more meaningful and memorable than taking a photograph from a safe distance, with no interaction. You want to experience life: be an active participant, not just an idle observer. You'll come away from the encounter better informed and feeling empowered, and, perhaps, with a strong photograph as proof. What better way to express yourself creatively than with a memorable image of that meeting that others can relate and respond to? We're all involved with online social networking, but honestly, there's nothing like meeting someone new, chatting them up a bit, then making a revealing portrait of them. Yes, social networking with a camera may be a bit slow and challenging, but it's guaranteed to make your life far more interesting and meaningful than just posting a quick snapshot to your friends on Facebook, Instagram, Snapchat, or to whatever is the currently hot photo-sharing app. It's such a paradox that with all our digitally enhanced communication, the result is *less* human contact and real connection. But in the process of making an interpretive portrait, we can have an intimate and emotional connection with our subject. We should strive to make images that are more impactful than just another smartphone grab shot that will disappear quickly in the ephemeral image universe that can often benumb us online.

From the very invention of photography up to the present, many of the images that have become visual icons have been taken by photographers who had the courage to photograph strangers in their natural environment. Whether it's a caught moment or a posed portrait, those are the images that have changed our impression of other cultures, as well as the people in our own. And with a bit of effort, you too can make insightful, intriguing photographs of people you're attracted to for whatever reason, people that you normally wouldn't meet, people that just might move you and stir your soul—all with the click of the camera shutter.

And the results will be like those you are about to see . . .

Max James Fallon
San Francisco

When I photograph, I strive to create a relationship between the subject and the background with my composition and lighting—a strong sense of place and context. But to approach people in their own environment, you need to appear confident, friendly, and enthusiastic, with an in-control demeanor, so your subject will be more at ease and willing to partner with you, even when there's no verbal communication, as in this situation.

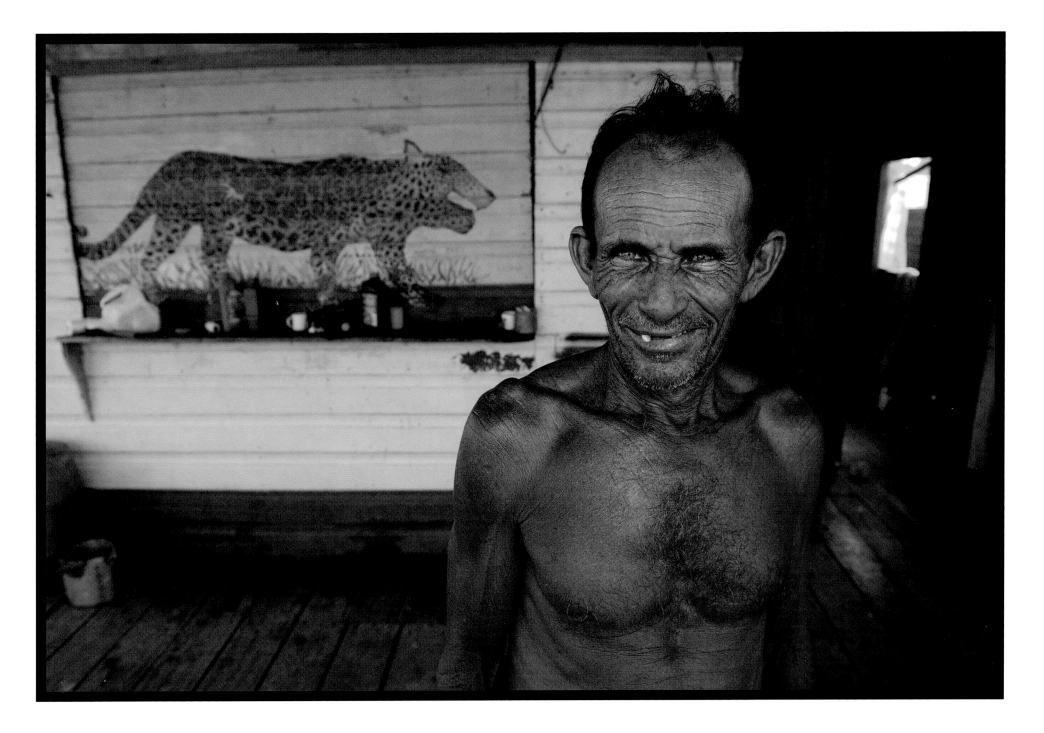

Jaguar Man ∫ Amazonia, Brazil 2012

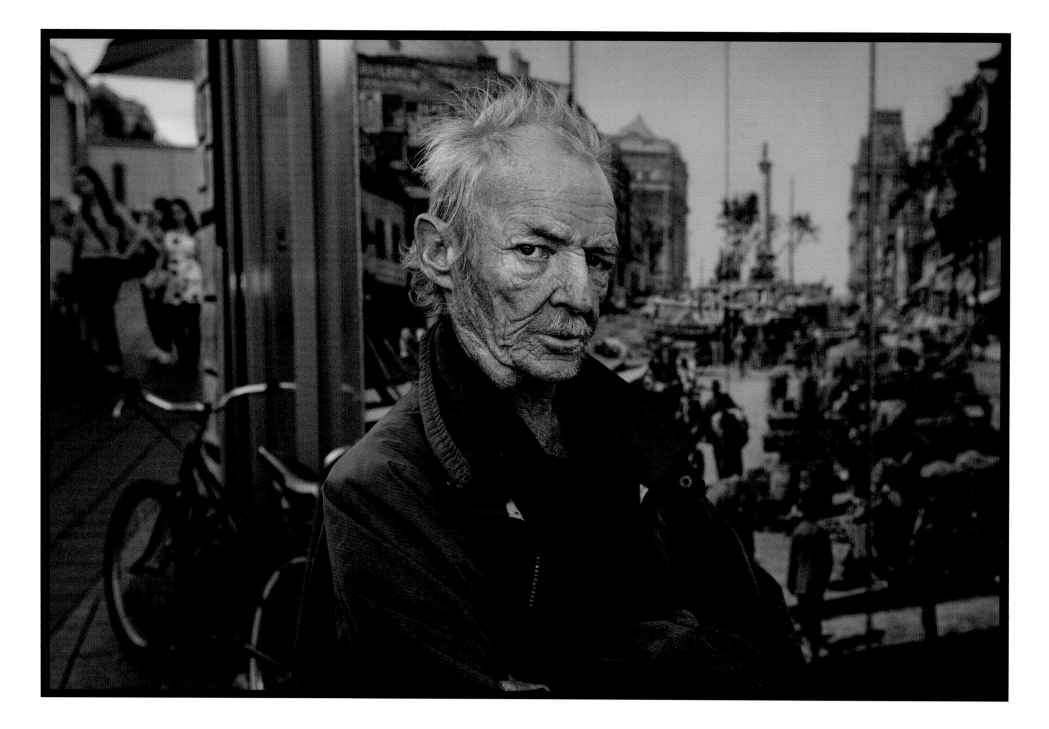

Place Jacques-Cartier ∫ Montreal 2014

Walking through the streets of New York or wherever I find myself, I'm always looking for moments to photograph, mainly of people. There is that split second rounding a corner where you make eye contact with another human being and for a brief instant their public mask is down. You connect to the other. This connection is the main event for me as a photographer and part of a practice for understanding who I am and my own place in the world. Sometimes I'm looking for what I have in common with my subject, other times I'm defining myself in opposition or learning something. We all are looking for some kind of meaning when we look at still images, which is why they still exist. So when I raise my camera, this is my prayer for meaning in a sometimes meaningless world, 1/125th of a second long.

Doug Menuez ʃ *Documentary Photographer, Filmmaker New York*
His latest book is Fearless Genius: The Digital Revolution in Silicon Valley 1985-2000.
www.menuez.com www.fearlessgenius.org

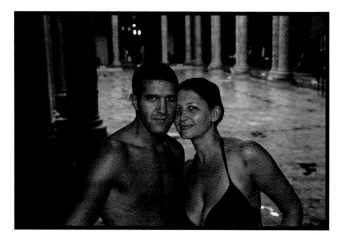

I attempt to instill my photographs with a clarity that pulls the viewer into the formal composition, allowing them to relate to my subject on various levels of their own experience.

Gellért Baths ∫ Budapest 2013

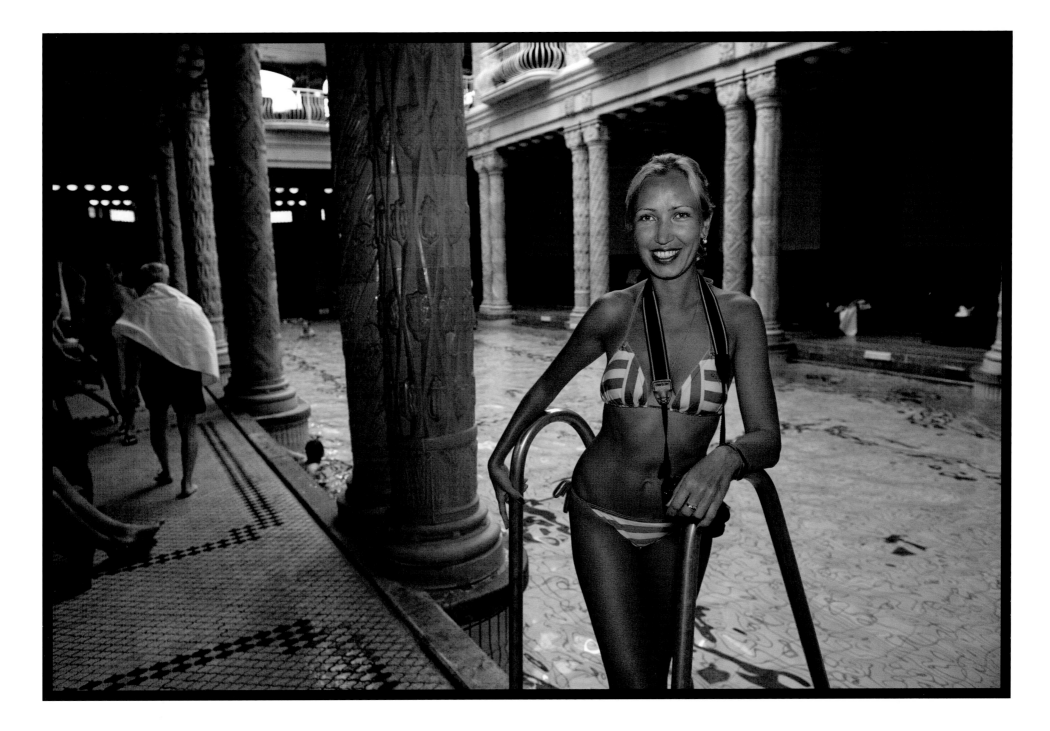

Russian Tourist ∫ Budapest 2013

The importance of eye contact for making our society healthy and whole is undeniable. As a sociologist, I'm increasingly distressed by the way that our culture teaches us to avoid making eye contact with passersby, and certainly never to talk to strangers.

But should we talk to strangers?

A half-dozen recent studies demonstrate the power that connecting with people we don't know has to make us happier. (Research also suggests that that talking to strangers makes us luckier.)

In one study, researchers randomly assigned volunteers to talk to the strangers who sat down next to them on the train during their morning commutes. Pretty much no one thought they were going to enjoy giving up their solitude to make small talk with someone they didn't know and would probably never see again. But guess what? The volunteers enjoyed their commutes more than the people in the study who got to read their books and finish their crossword puzzles in silence. What's more, not a single study participant was snubbed. Other research indicates that the strangers being chatted up in public spaces similarly think they won't want to talk, but then end up enjoying themselves.

In another study, researchers measured how much people enjoyed interacting with people they barely knew, and how much they enjoyed connecting with loved ones. Turns out that interacting with both types of people made both introverts and extroverts happier—and the more social interactions they had, the happier people were.

Finally, research shows that even just acknowledging someone else's presence by making eye contact and smiling at them helps people feel more connected. So yes: talking to strangers strangely makes us happy.

Christine Carter, PhD ∫ *Senior Fellow, UC Berkeley's Greater Good Science Center*
Author of The Sweet Spot: How to Find Your Groove at Home and Work

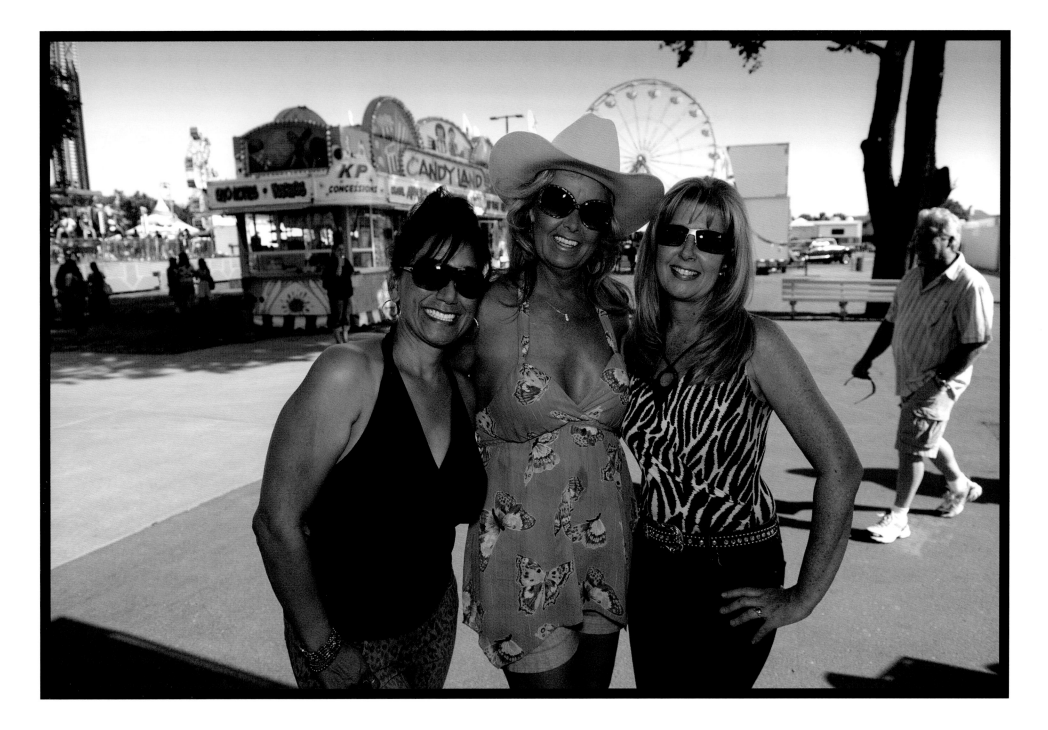

County Fair ∫ California 2012

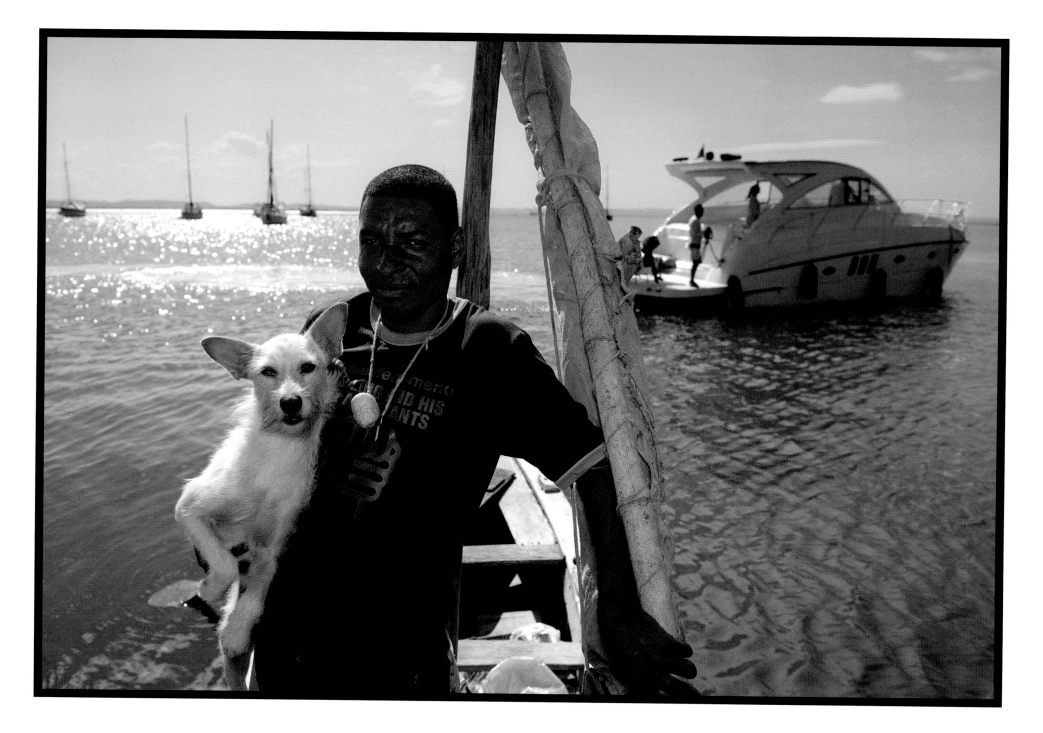

Ilha de Itaparica ∫ Brazil 2012

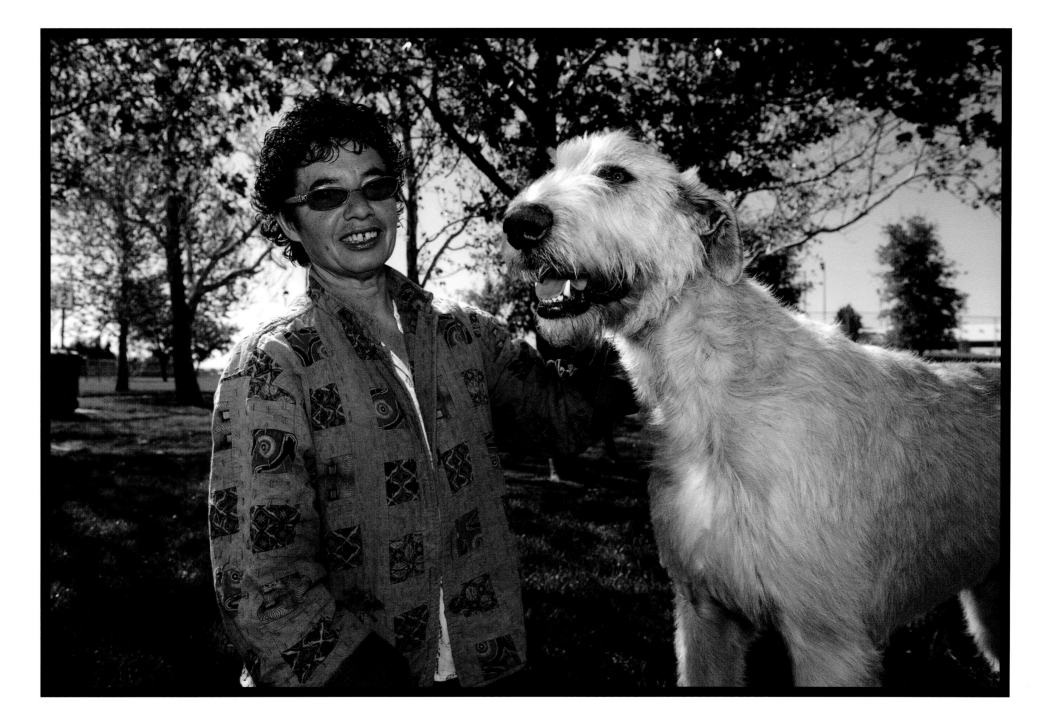

Wolfhound Portrait ∫ California 2012

Someone interesting catches your attention. First of all, be patient. Wait for an opening.

• Smile

• Eye contact

• Have your camera out, but not up to your eye

• Chat them up (Conversation101)

• Ask questions about them and their environment

• Bring up the possibility of a photograph

• Explain why you want to photograph them and what you'll do with it

• Promise to send them the photo later on, if possible

• Look through the viewfinder and experience the connection you've made!

Personal encounters may or may not result in a photograph. But ideally, when they do, the subject will reveal something about themselves in the process that you can capture with your camera. Embrace uncertainty. Adapt to new situations and environments. It will make your life far more meaningful and rewarding. Hey, it may even get your adrenaline flowing!

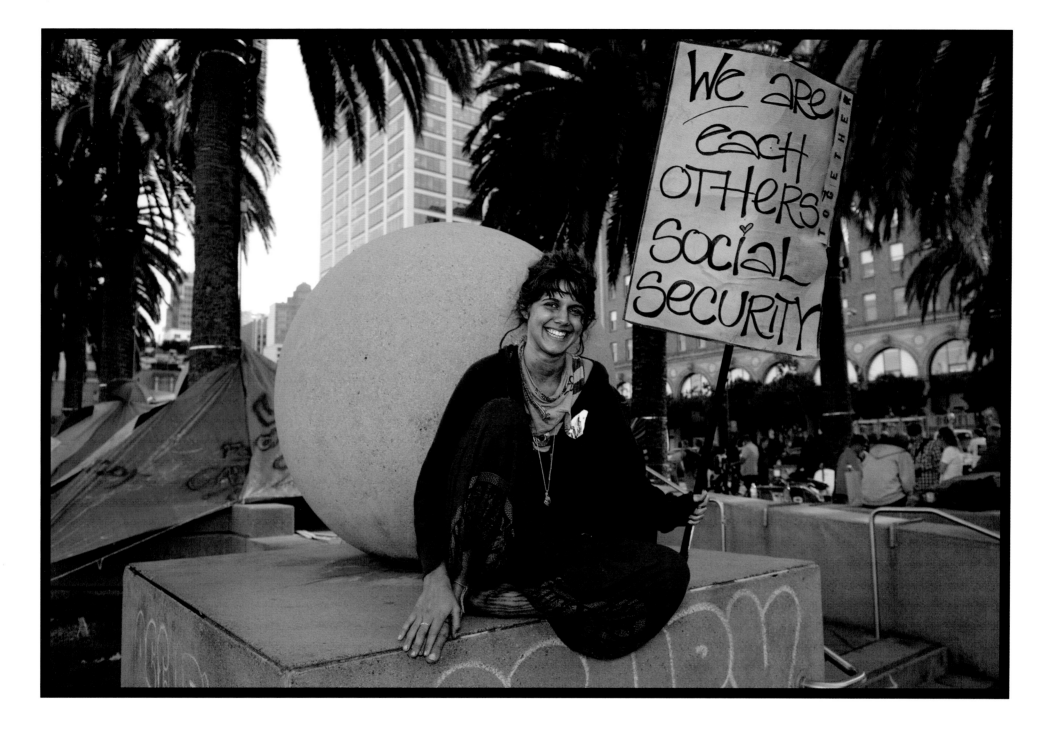

Occupy Movement ∫ San Francisco 2011

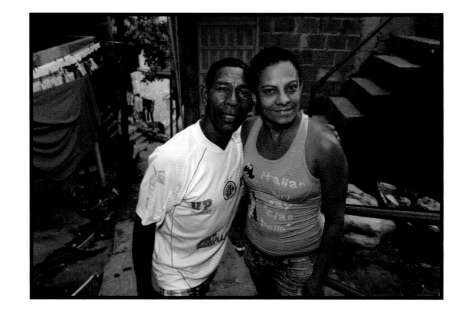

It's about starting a dialogue. *"Posso tirar uma foto de voce?"* A simple question, asking permission to photograph, in whatever language is spoken, then seeing where it takes me.

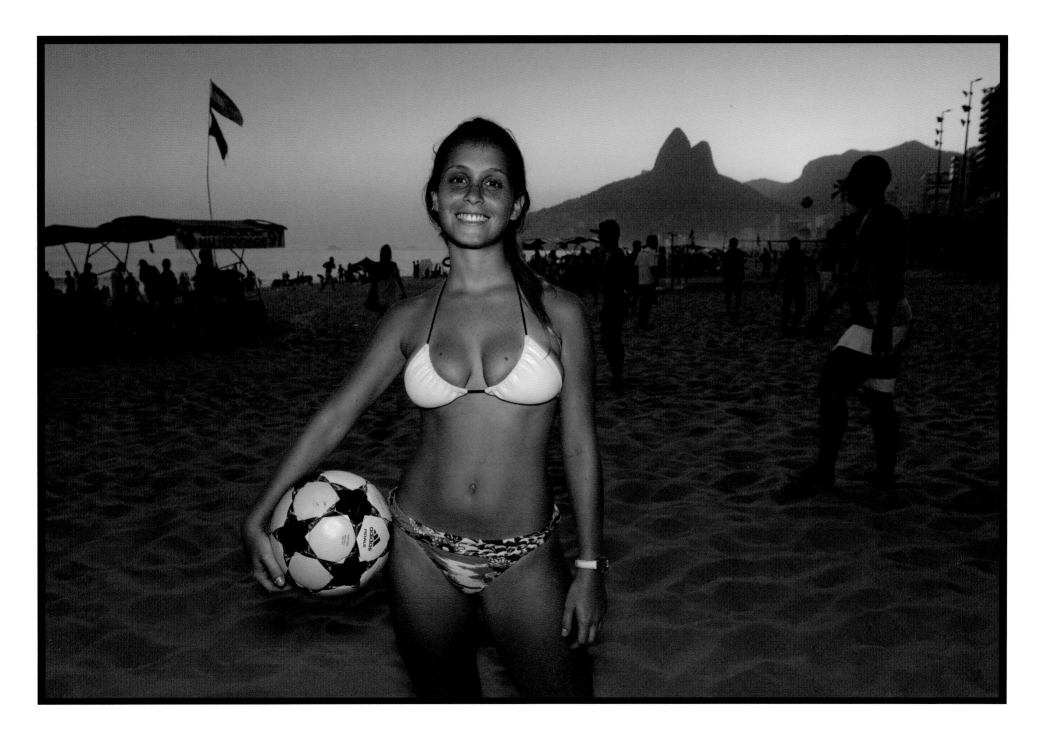

Ipanema Sunset Smile ∫ Rio de Janeiro 2012

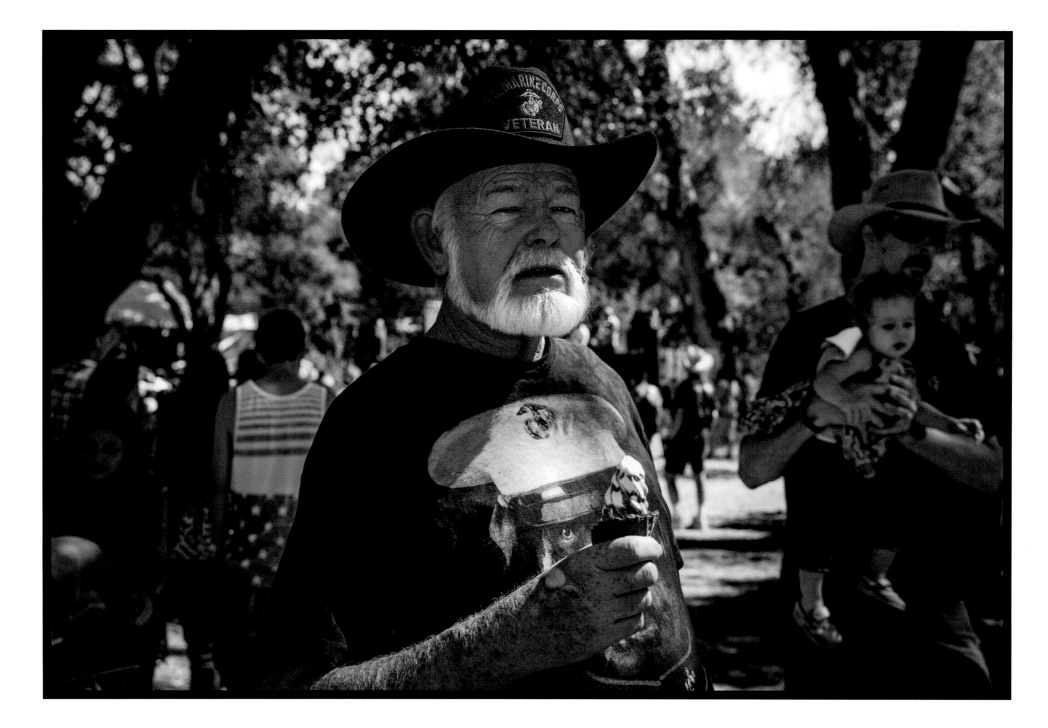

Proud Marine Veteran ∫ California 2014

Making eye contact is very important to me. I then wait for that
moment when subject and environment complement each other,
resulting in an image that allows the viewer to make the connections.

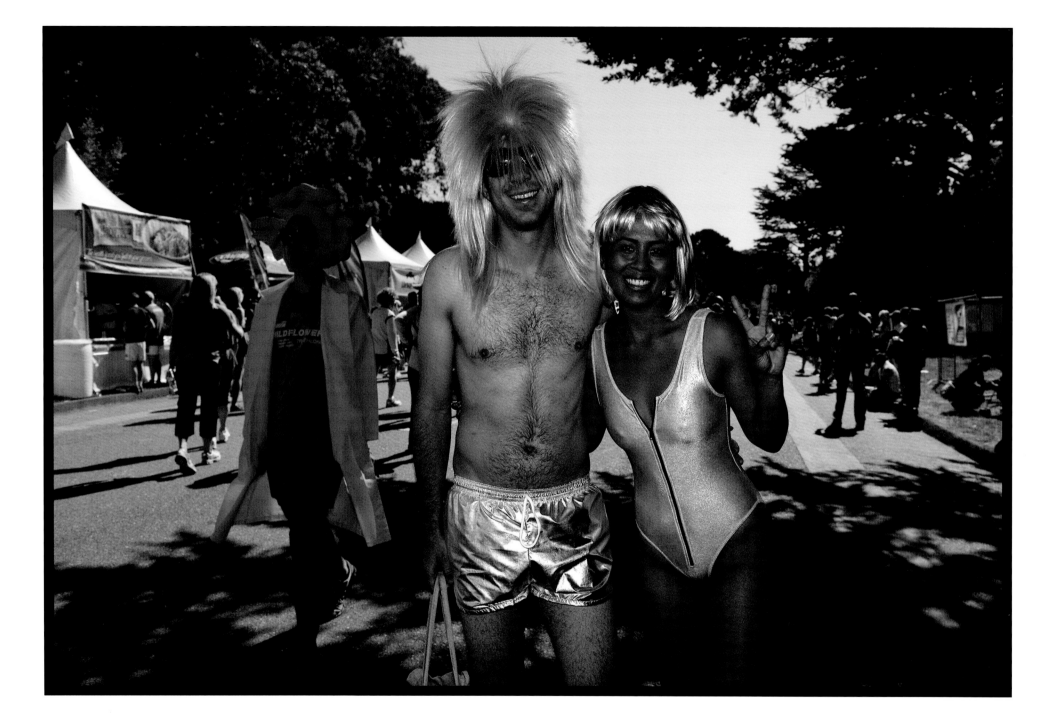

Bay to Breakers Race ſ San Francisco 2012

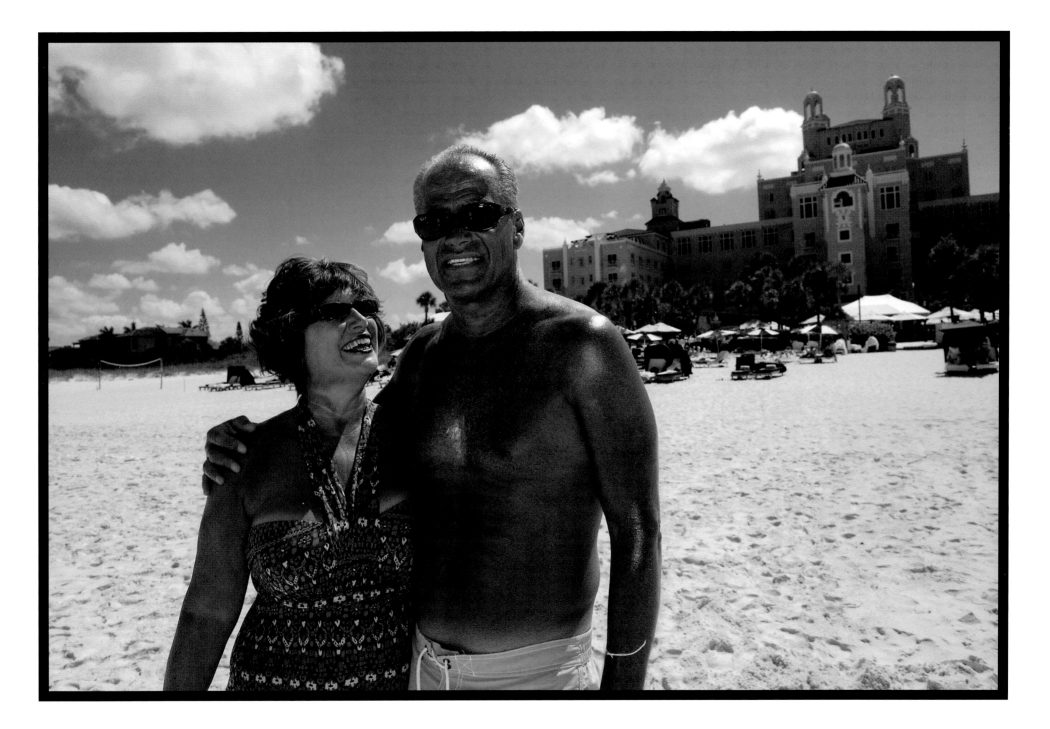

Resort Couple ∫ Florida 2011

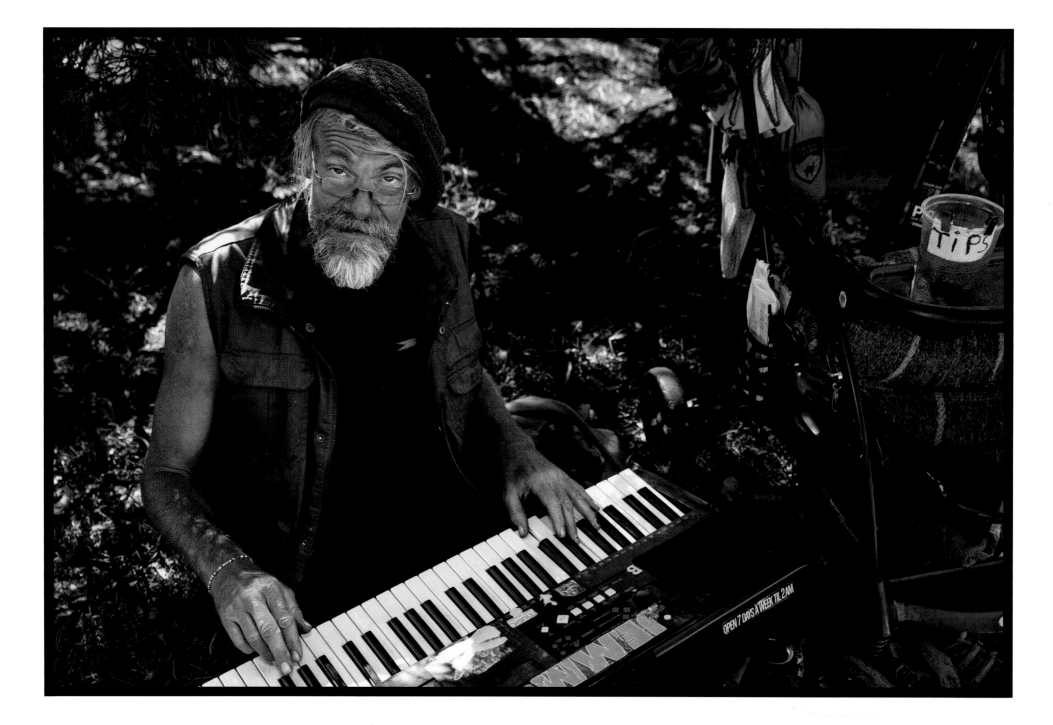

Jazz Pianist ∫ San Francisco 2014

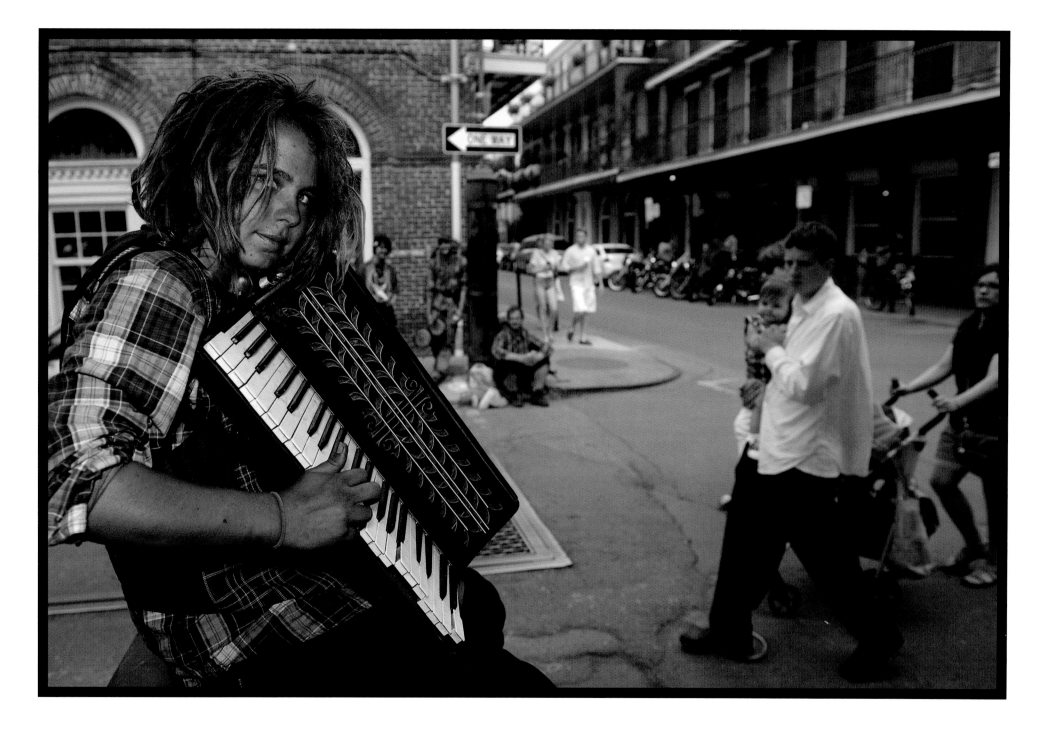

Accordionist ∫ New Orleans 2013

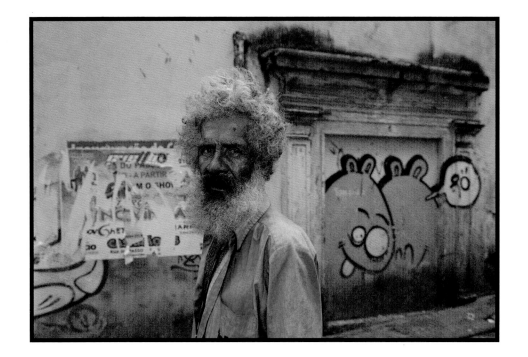

But in the moment the picture itself is shot, it's just you and your camera: no distractions, no itinerary. You're wandering through an historic neighborhood, exploring with your eyes wide open; focusing on the environment and the people in it, going about their daily routine. Observe the architecture, the flow, how the light illuminates the people. What makes an impression on you? Is anyone standing out visually? Anyone noticing you? Should you approach them? Start a conversation?

Graffiti Wall ∫ Salvador, Brazil 2012

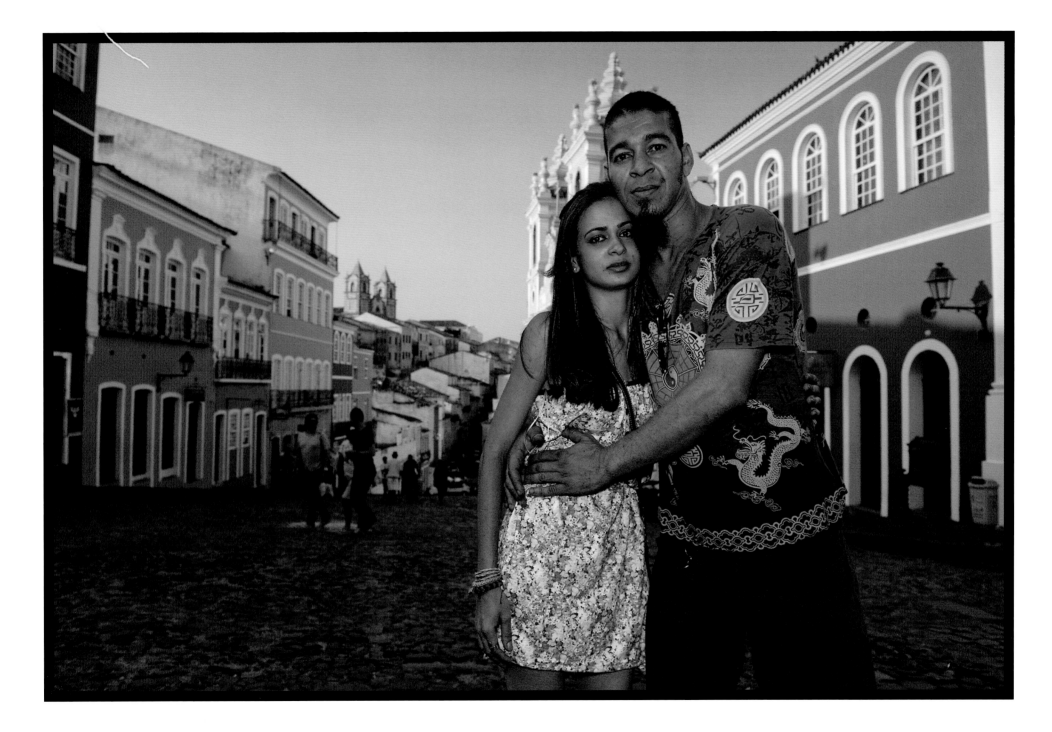

Couple in Pelourinho ∫ Salvador, Brazil 2012

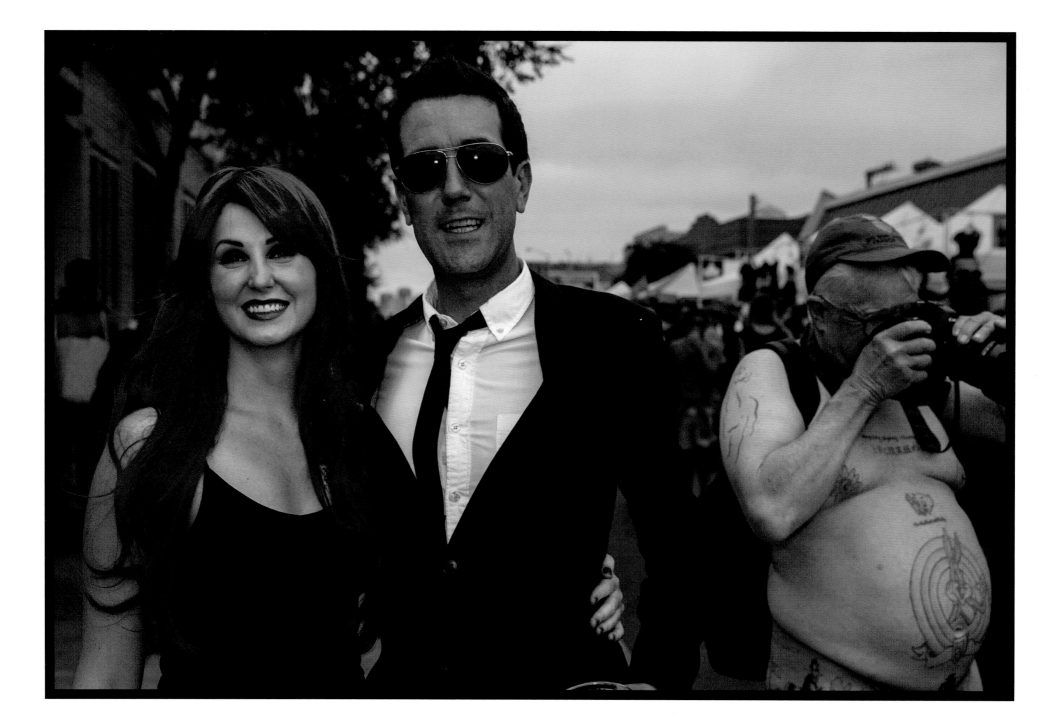

Folsom Street Fair ʃ San Francisco 2014

Széchenyi Spa Couple ∫ Budapest 2013

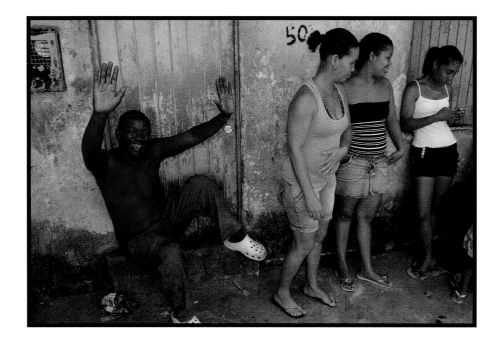

Facing the imminent possibility of blindness, this man, with his concerned wife, had just finished praying for a miracle with a priest at the Church of Nosso Senhor do Bonfim. Built in 1754, it's the most famous church in the state of Bahia, widely known for its miracles and cures for its ardent believers. Many of its faithful practice a blend of Afro-Brazilian Catholicism, which has remnants of the religious beliefs and culture from their slave history. On this Sunday, the main sanctuary was jammed with devout parishioners and tourists loudly praying for their own small miracles, unaware of this poor man's plight.

In another area of this huge city *(above)*, a very different scene presented itself in the sprawling Calabar favela. We traversed a maze of alleys and stairways in the late afternoon heat, finding mostly friendly, curious residents such as this man, but also some who took a more threatening stance. We would have stayed longer, but my camera was not always welcomed, nor was I. It's difficult to be unobtrusive in such situations, but being friendly and confident certainly helps.

Calabar Favela ∫ Salvador, Brazil 2012

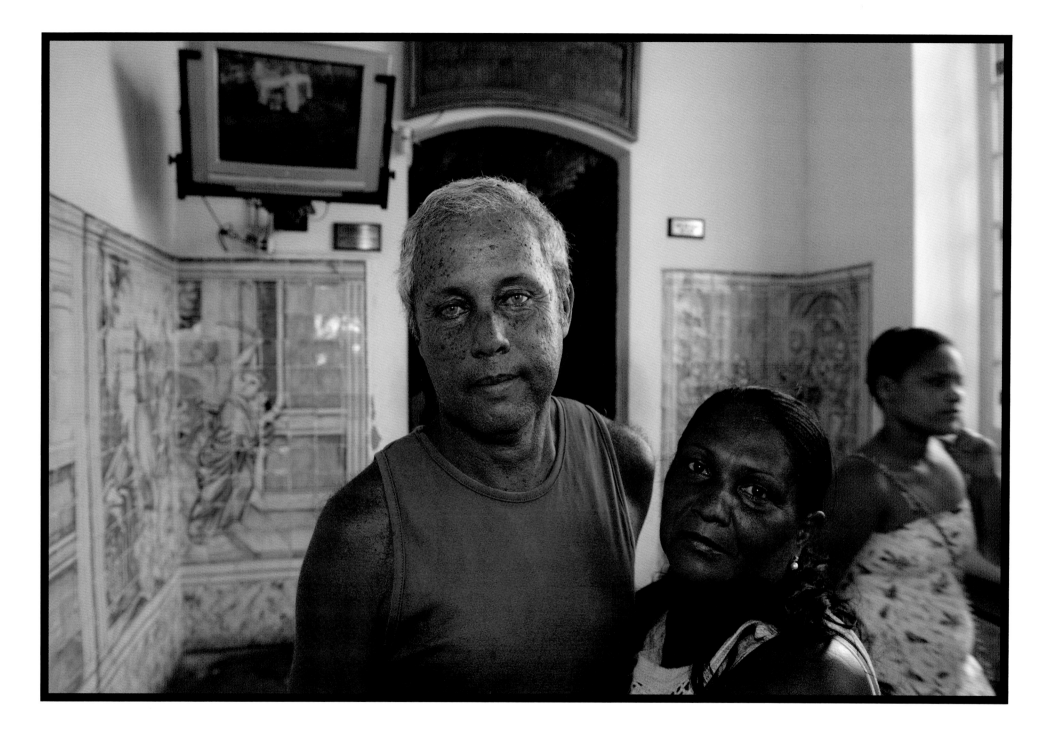

The Church of Nosso Senhor do Bonfim ∫ Salvador, Brazil 2012

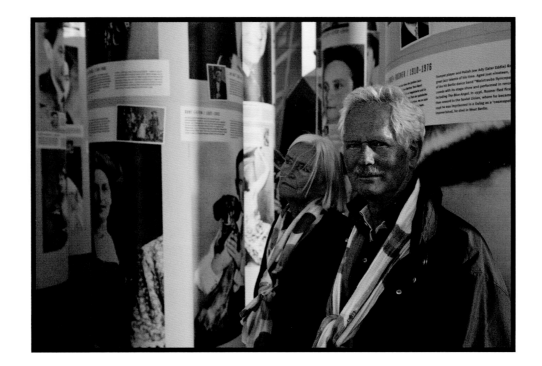

In 2013, I was visiting Berlin, which was having citywide exhibitions and events that year with the theme "*Zerstörte Vielfalt – Berlin in der Zeit des Nationalsozialismus*" (Diversity Destroyed – Berlin in the Nazi Era). My curiosity pulled me into this very moving outdoor exhibit; I wanted to talk to some of the locals who were walking quietly around the columns that displayed portraits of famous German artists executed or exiled at the hands of the Nazi regime. I was curious to hear how these poignant portrayals affected German citizens born after the war. This young woman *(right)* was reflecting on the artistic contributions these individuals made to Berlin culture in the late 1920s and 1930s, and how she and her contemporaries relate to these creatives who were so tragically lost. I knew I wanted to shoot from right in the middle of the display; the graphic elements of the monumental portraits presented such a compelling background.

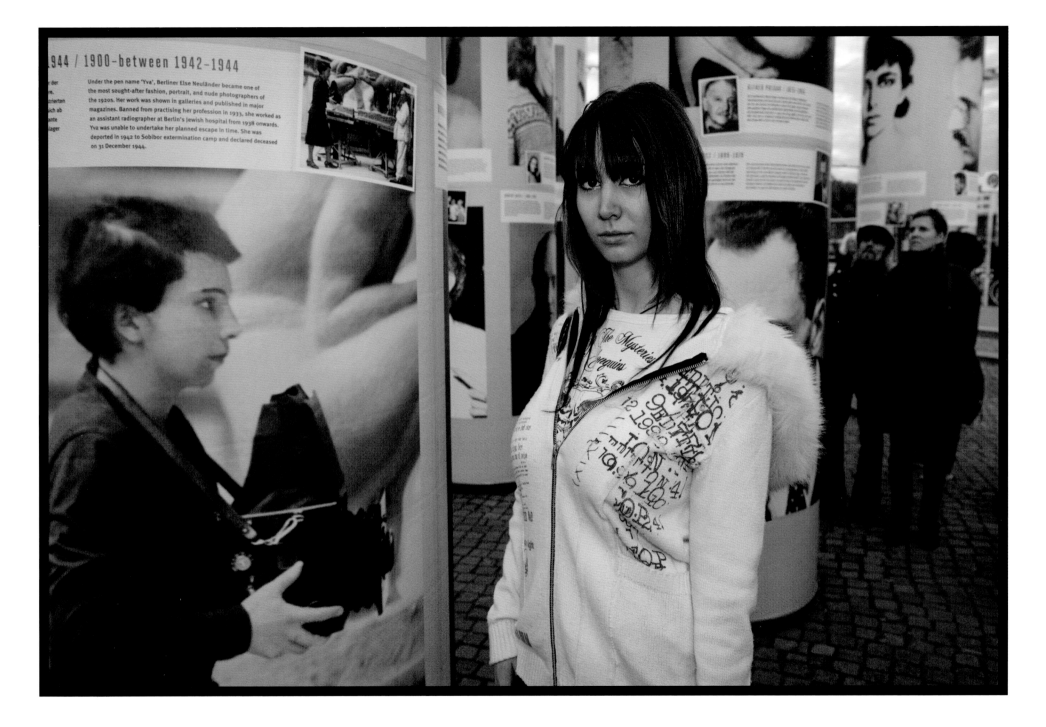

Within the image, the following text is visible:

1944 / 1900–between 1942–1944

Under the pen name 'Yva', Berliner Else Neuländer became one of the most sought-after fashion, portrait, and nude photographers of the 1920s. Her work was shown in galleries and published in major magazines. Banned from practising her profession in 1933, she worked as an assistant radiographer at Berlin's Jewish hospital from 1938 onwards. Yva was unable to undertake her planned escape in time. She was deported in 1942 to Sobibor extermination camp and declared deceased on 31 December 1944.

Diversity Destroyed ſ Berlin 2013

Old Mill by the River ∫ Upstate New York 2014

I'm after an atmosphere of trust in my portraits. I want the subject to reveal a bit about themselves for the camera lens, so we need to form a bond—starting with that eye contact.

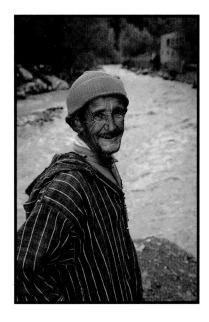

The easiest way to make compelling, real photographs of people is by being authentic. Making candid images of people is not a trick. It's a skill a photographer can develop, which requires respect for the subject and building a relationship in the time you have together. Successful pictures of people almost never happen from a distance. Put away the telephoto lens and become part of the moment.

Talk to people. Whether it's simply a nod of acknowledgement, a greeting, an explanation of what you're doing, or a long involved conversation, connect with the people you are photographing. Remember, we have more in common with each other than you might think. Don't look at people as different or exotic. Rather, focus on the things that unite and bind us.

Your subjects are giving of themselves. Don't abuse their gift of sharing their lives. Don't treat them like models. Send back some prints, cherish the moment, and treat them well. Don't promise if you don't intend to deliver. In this age where many people are digitally connected, it has become easier than ever to email a jpeg to an address for your subjects to share.

Ami Vitale ∫ *Photojournalist, National Geographic Photographer, Nikon Ambassador*
www.amivitale.com

Flooded River ∫ Morocco 2010

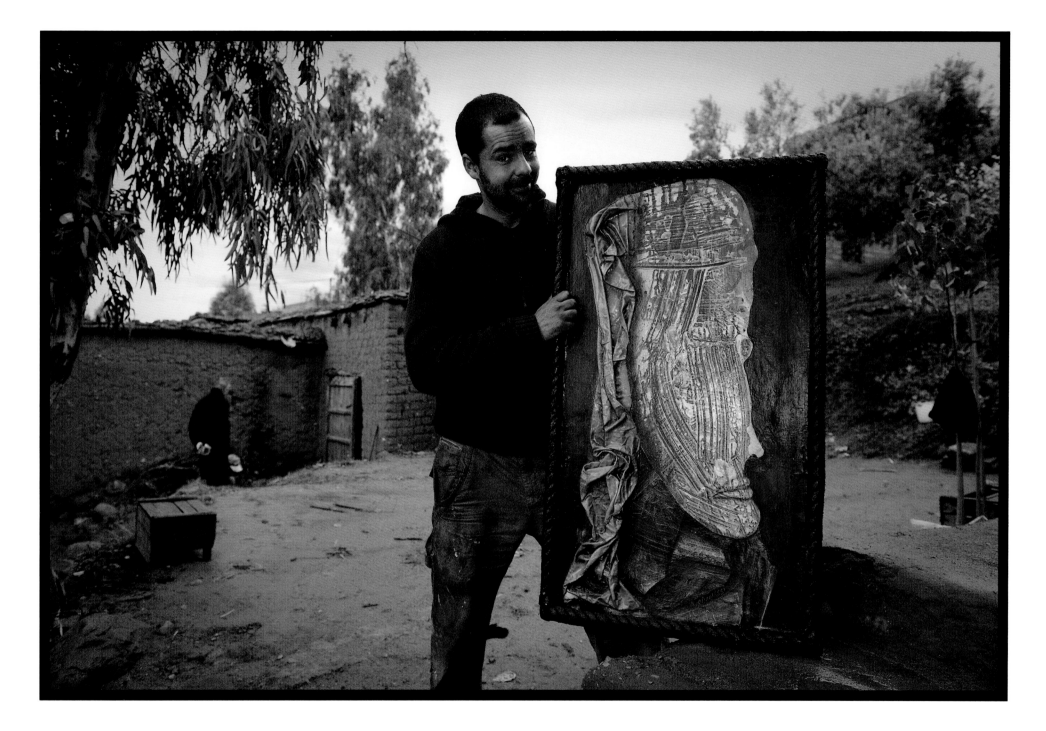

Mixed Media Artist ʃ Atlas Mountains, Morocco 2010

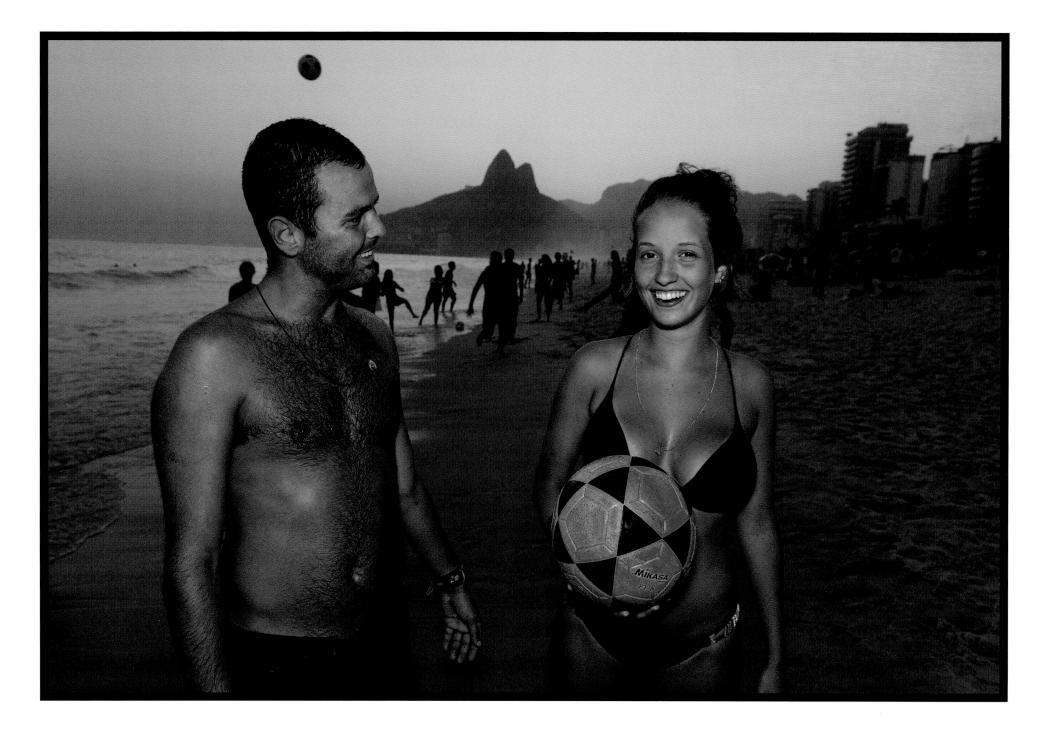

Beach Futebol | Rio de Janeiro 2012

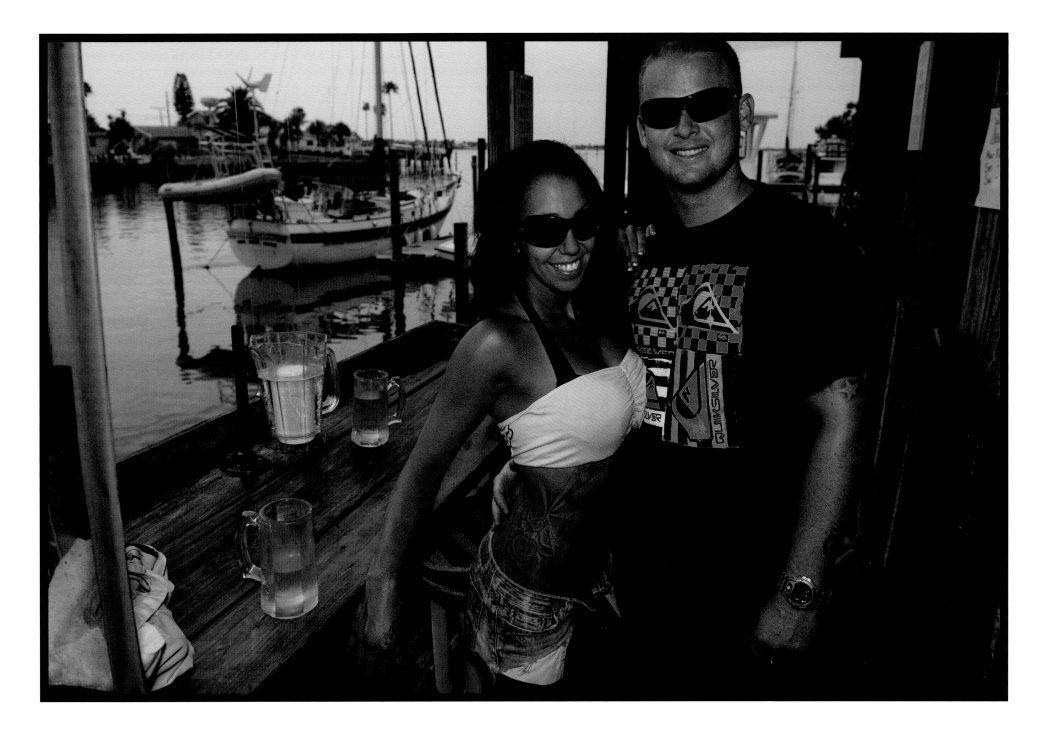

Vacationing Couple ∫ Florida 2011

Years ago I was photographing indigenous people for my son, who was working on an anthropological project in Peru. He asked me, "How do I manage to get the images I do with people that I can't communicate with?" I had to take some time to be able to answer his question and, after some self-reflection, I told him that it had to be my energy that I am communicating with my subjects. I come to them with an attitude that I am going to take a special photo, that they are important, and that we are not going to rush; together we are going to create something exceptional that will tell your story. I think it is my confidence that I can do this that gets communicated in a nonverbal manner.

When I teach photographers about photographing people, I tell them it is important to relax, not rush, because if you feel anxious and feel that you are intruding on your subject, they will pick up that energy, and you will wind up with an image that is not satisfying and superficial. Creating empathy with your subject will go a long way in creating images that are meaningful.

Mark Tuschman ∫ *Author of:* Faces of Courage: Intimate Portraits of Women on the Edge *(2015)*
www.tuschmanphoto.com

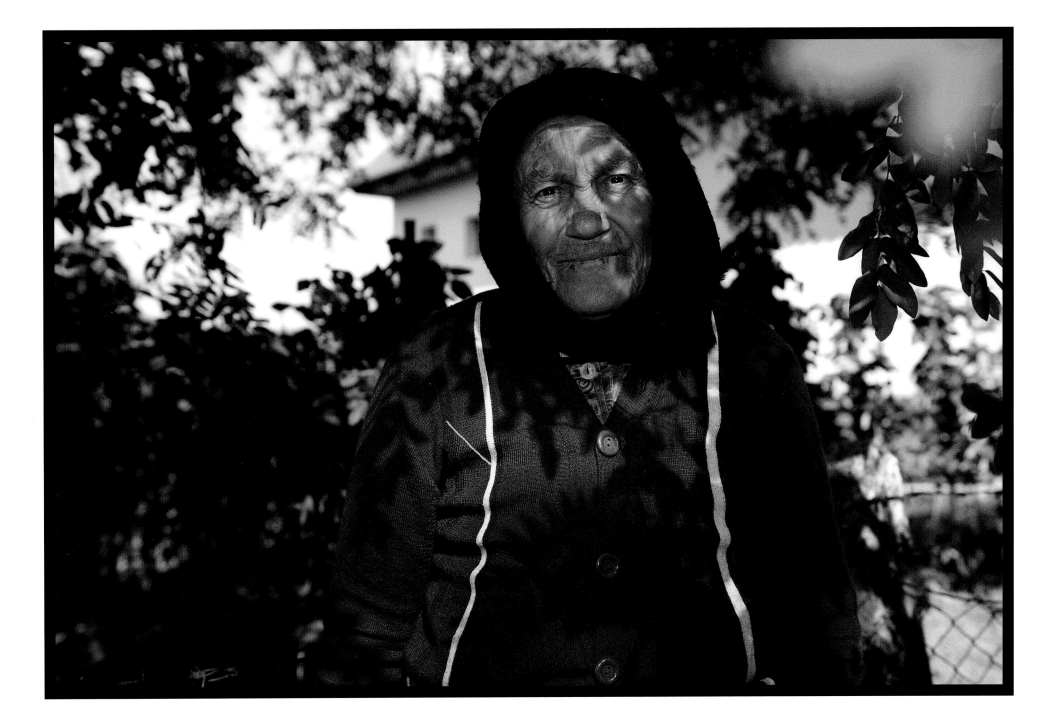

Woman in Hollókő ∫ Hungary 2013

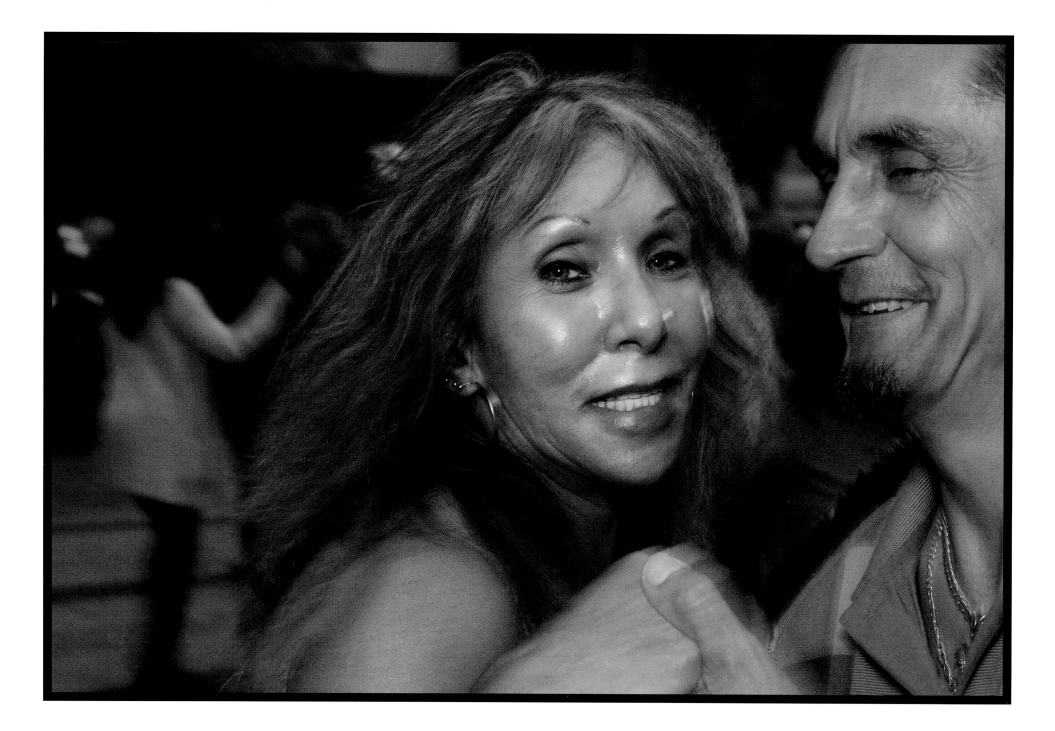

Salsa Dancers ∫ San Francisco 2014

My intent is to isolate a single frame from a culture's endless movie reel that reveals something meaningful and true about it, and if I can make it visually arresting, all the better.

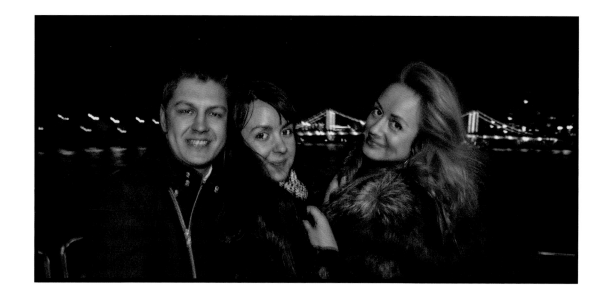

I know a photographer who's spent more than forty years traveling the world, making connections with perfect strangers. Even though he may not speak their language, he always seems to earn their trust and gets them to open up to him. His images reflect that—they feel almost like photos of friends or family members. They feel universal.
He once told me that everyone hides behind a façade, and his job is to get past that. Clearly, he loves his job.
All these years later, he is as passionate about connecting with people as ever. It's inspiring. (Keep at it, Max!)

Bill Stockland ∫ *Photographers' Representative (Stockland Martel) New York*
www.stocklandmartel.com

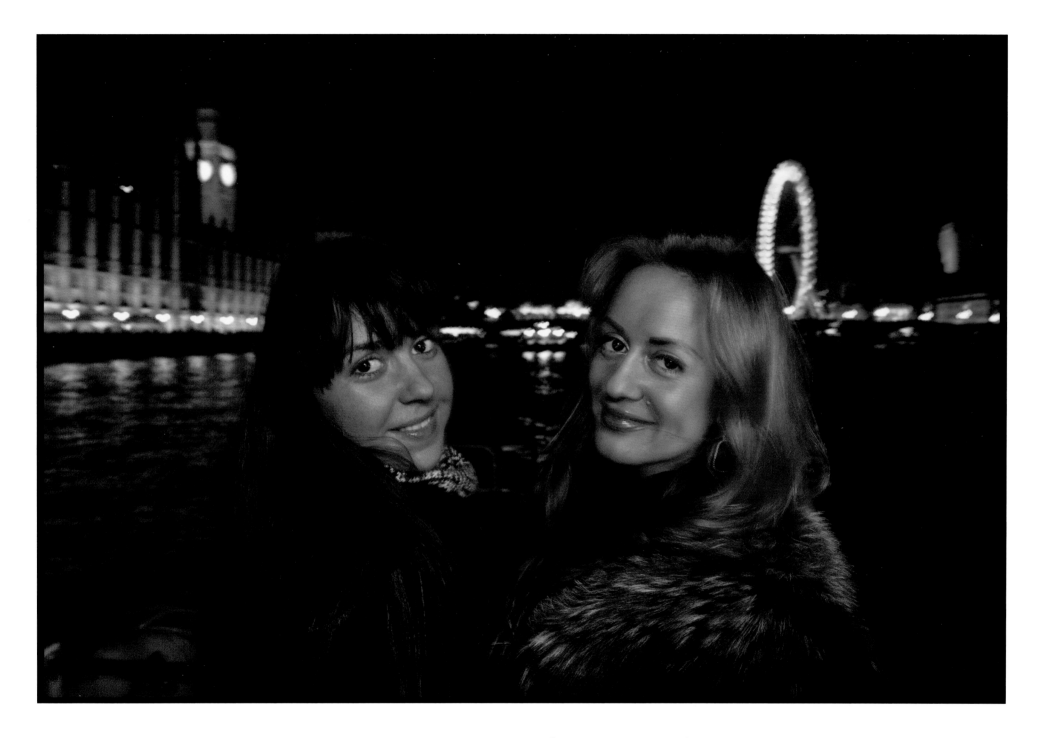

Ukrainians on New Year's Eve ∫ London 2014

Push yourself to photograph even when you're not really interested or motivated. You may find that once you're out in new and unfamiliar surroundings and looking through your camera's viewfinder at the scene unfolding before you, you'll become very interested.

Uncomfortable situations can occasionally produce great photographs. Head down that alley, or over to that group on the corner: you may just find what you didn't know you were looking for!

Are you being followed by overly "interested" observers? Blend in with the crowd, pop into a store, take a taxi to another area. New subject possibilities may suddenly present themselves just when you thought nothing interesting was happening for you and your camera. And always, safety first!

It suddenly starts to rain, hard. Your camera may get a bit wet, but it may also present you with some wonderful opportunities to find great subjects sheltering, just like you. Bad weather is your friend: it enhances the light, adds drama to a dull situation, causes people to react differently, and changes the overall mood of a situation. Snow? A somewhat similar situation, but, mostly, people are just going inside to warm up, leaving you out in the cold.

If the light or atmosphere isn't inspiring, come back later when it is. Great photographs don't necessarily happen the first time around. In fact, they usually happen under difficult or trying circumstances. There are not a lot of memorable photographs made at croquet matches. But maybe you could change that!

Is your subject speaking to you nonverbally? Are you responding visually? Just stay focused and keep shooting. You may be pleasantly surprised when you edit and one of your shots jumps out from all your other images. It'll put you right back in the situation and you'll be very pleased that you didn't give up and move on after only a couple of shots!

Don't fear failure or rejection, just keep at it. I get *lots* of rejection while photographing!

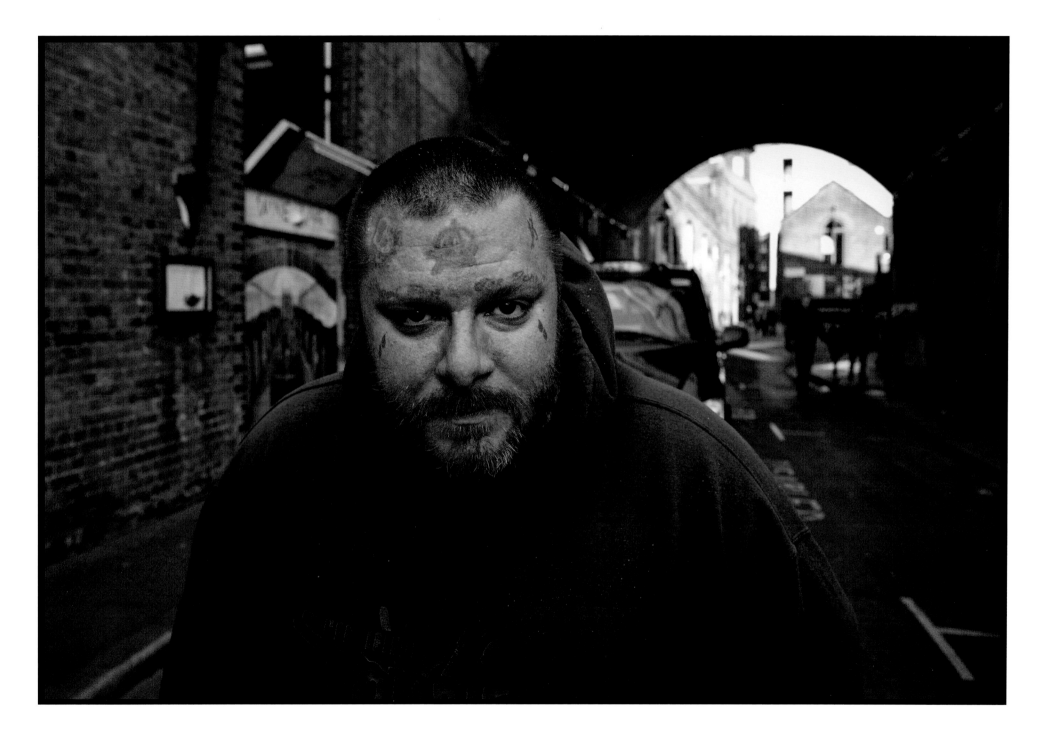

Tattooed Face ʃ London 2014

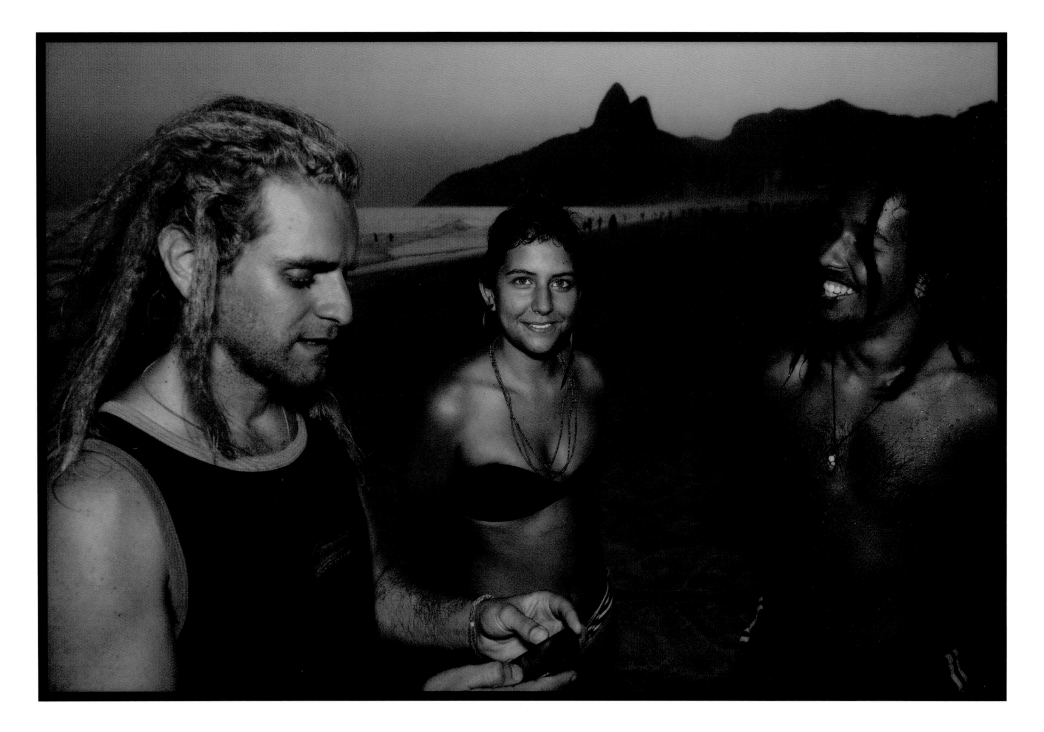

Rio Beach Trio ∫ Brazil 2012

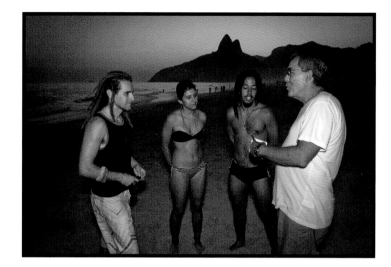

Working as a producer means facing a new challenge every day. Working with different people is always a gift, because it enables you to absorb different points of view. Meeting Max Fallon was a nice surprise. Introduced by a mutual friend, a great photographer in New York, Doug Menuez, he had the best recommendations. We had great fun during his days in Rio, then on his way to other cities in Brazil, photographing for his latest book. He's one of those privileged people that has the talent to blend into any kind of environment. He knows how to make his life easy as well those around him. He's as cool as his shots, and his pictures are great because he is who he is.

There is not a perfect formula to approach an unknown person, but it has to be soft and direct. You must show a smile. Straight, slowly but surely. It has to be like a quick ping-pong game, when you find what disturbs or pleases the person you want to photograph, and use what pleases them.

In that specific picture I remember mentioning the importance of sports in one's life and how Rio people love sports. They agreed and slowly felt comfortable. I let them talk and was positive. "Max is taking pictures about the good things of Rio for his book; would you like to be part of it?" I try to blend using the same dialect, to make myself understood and get the job done. A bit of a *cara de pau* [poker face] always helps!

Flavio G. Chaves ʃ *Producer/Translator Rio de Janeiro*
www.caipirinhafilms.com

The last book legendary music photographer Jim Marshall published was titled **Trust**. Jim had to
have all access, all the time, something that was not a problem early in his career, but that in time became
nearly impossible. If you didn't trust Jim and he didn't trust you, there was no photo session. Jim was
the first photographer I documented for my *Behind Photographs* book. I gained his trust and, in turn, Jim
would become both a huge advocate for my project and a good friend. Over five years I photographed
over 150 photographers, each time gaining the trust of my subject and building a network of support.

No matter how old or young my subject is, whether famous or someone I meet while traveling, I always
try to connect with them in order to put them at ease and establish a sense of trust. I take my cues from
their natural body language and get a feel from them of how they would like to be portrayed. When
possible, I ask questions like, "What is your favorite sports team?" "Do you have any pets?" "Who
is your favorite musician?" or "What was your first car?" The moment they start talking about
something they love and are passionate about, they begin to forget about the camera,
and we begin to establish something we have in common.

Making portraits is one of the most rewarding and enjoyable things in my life;
there is nothing better than hearing your subject say, "I love this picture."

Tim Mantoani ∫ *www.mantoani.com*

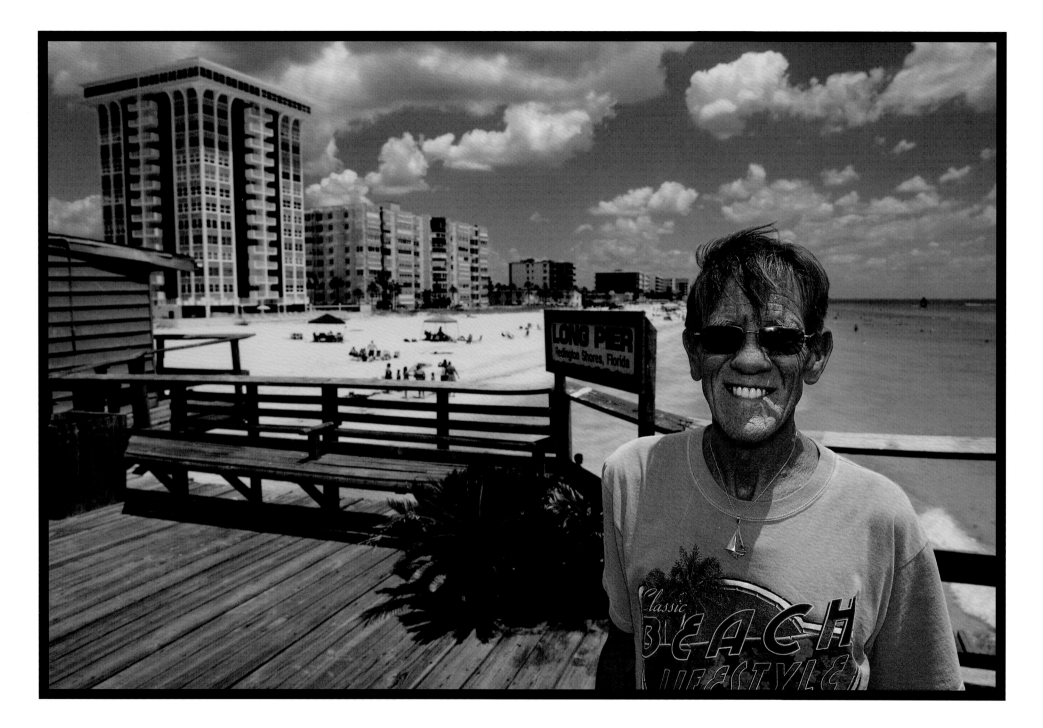

Long Pier ∫ Florida 2011

Experiencing new countries, the people of these countries, my eyes widen, my heart beats faster and my soul thrives for more. My first love other than my family is photography. I have had an amazingly blessed career with my camera. My camera has opened the door for me to visit some sixty countries in my thirty-five years of shooting. One of the foremost lessons I have learned through my travels is that no matter what country I'm in—the Philippines, China, Australia, Ireland, Puerto Rico, Jamaica, Italy, France, England—the people of every country are much the same as we are here in the U.S.A. We all want love and friendship, we want better for our children then we had for ourselves, and we all want peace in the world.

If everyone had the chance to travel the world there would be less bigotry, fewer prejudices, and more love. Travel has given me such understanding of just how similar we all are, how beautiful we all are in our own ways, and how much each different culture has to offer to other cultures around the world. The photographs I have taken from other countries have helped make me a world-class photographer. My books are mostly shot in other countries. I lecture often on my work, and I will start my speeches talking about photography being the big educator. Think about this for a moment: photography has taught most of us what war looks like; it has taught most of us what a nation struggling with famine looks like; what an AIDS epidemic looks like, and what a tsunami looks like. Most of us will never experience these devastating acts of pain-driven moments of life first-hand. But through a photograph, we are able to feel the pain that others go through, the triumphs or the losses others have experienced. Now put travel and a great photograph together and you have opened the mind to accept, believe, feel empathy, and know and understand the sameness in all of us. A very beautiful and enlightening acknowledgment of life. With great respect to all fellow travelers, carry on.

Sandro Miller ∫ *Photographer*
www.sandrofilm.com

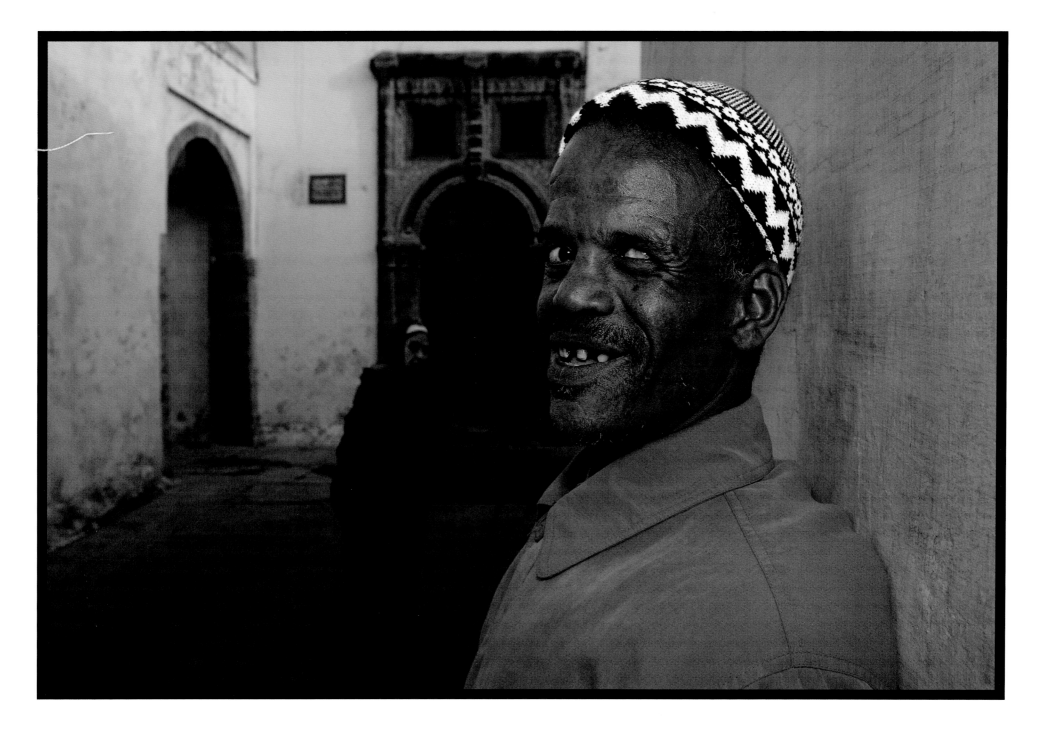

Quartier Habous Guide ſ Casablanca 2010

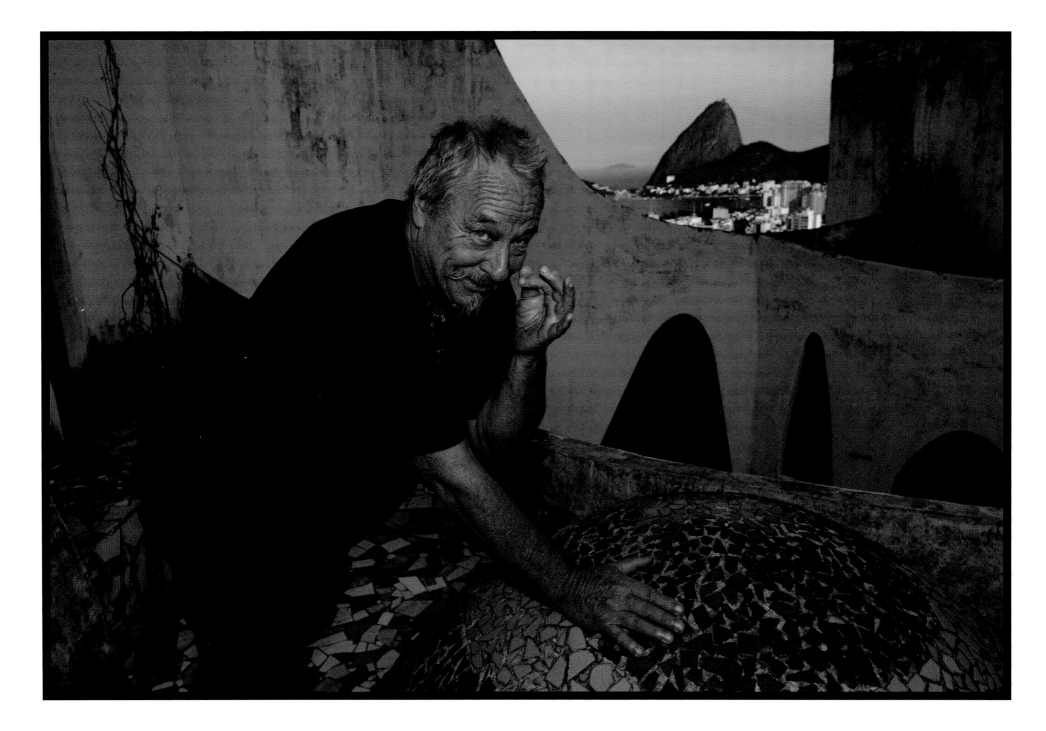

View from The Maze ∫ Rio de Janeiro 2012

Like most photographers, I'm drawn to unique individuals,
ambiguous situations, incongruity, humor, emotion … all the
while attempting to preserve a frame of cultural reference.

But the question is always: how do I turn my curiosity and
empathy for a subject into a unique and consistent vision
that communicates some universal truth?

The moment of connection with one's subject is essential in portrait photography. Although this pact can be elusive at times, our shared experience of being human is common ground enough to form an initial bond with our subject. Technical aspects aside, it truly is a connection, whether deep-seated or new, that will allow for the most sincere of portraits. As each individual possesses the ability to outwardly express the entire range of human emotion, there really is no wrong or right way to portray an individual. It therefore becomes the task of the photographer to capture the moment that seems befitting the subject.

As a commercial photographer, I am often asked to make strong portraits of individuals that I have only just met. This is also the case when approaching strangers on the street. The ability to connect on a human level is within us all. It is a far simpler task for some and cannot be taught, though it can be nurtured. Sincere connection must come from the heart. When it does, I believe the subject is able to detect its origins and as a result, offer the gift of collaboration.

Dan Winters ❬ *July 2015*

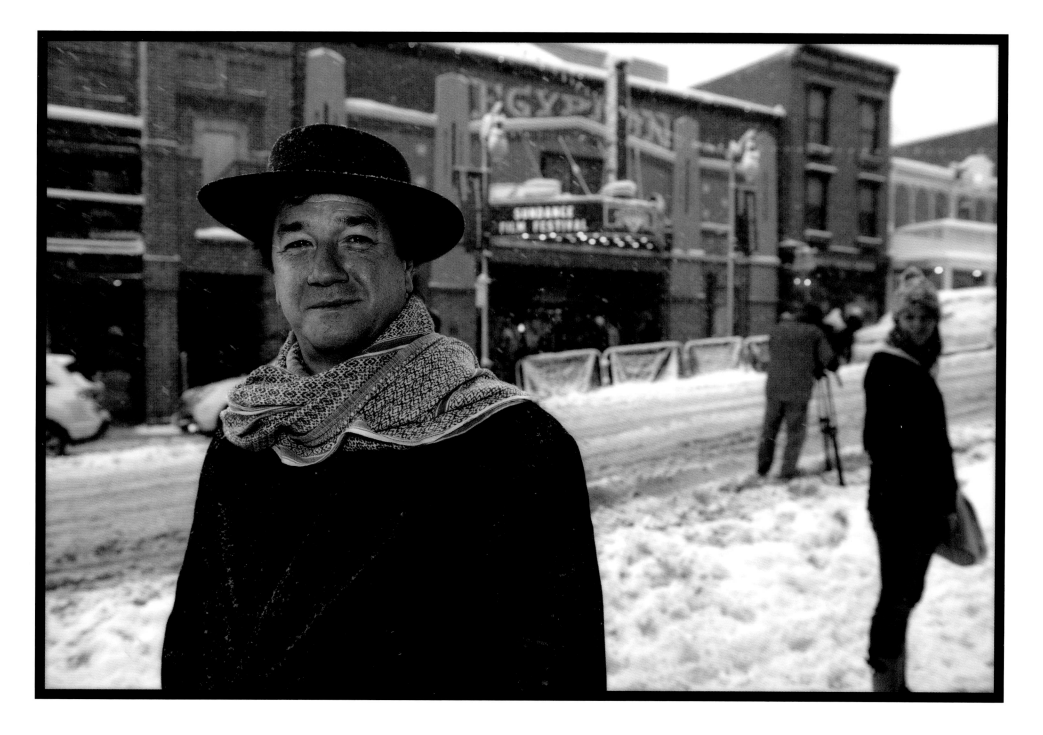

Sundance Film Festival **ʃ** Park City, Utah 2012

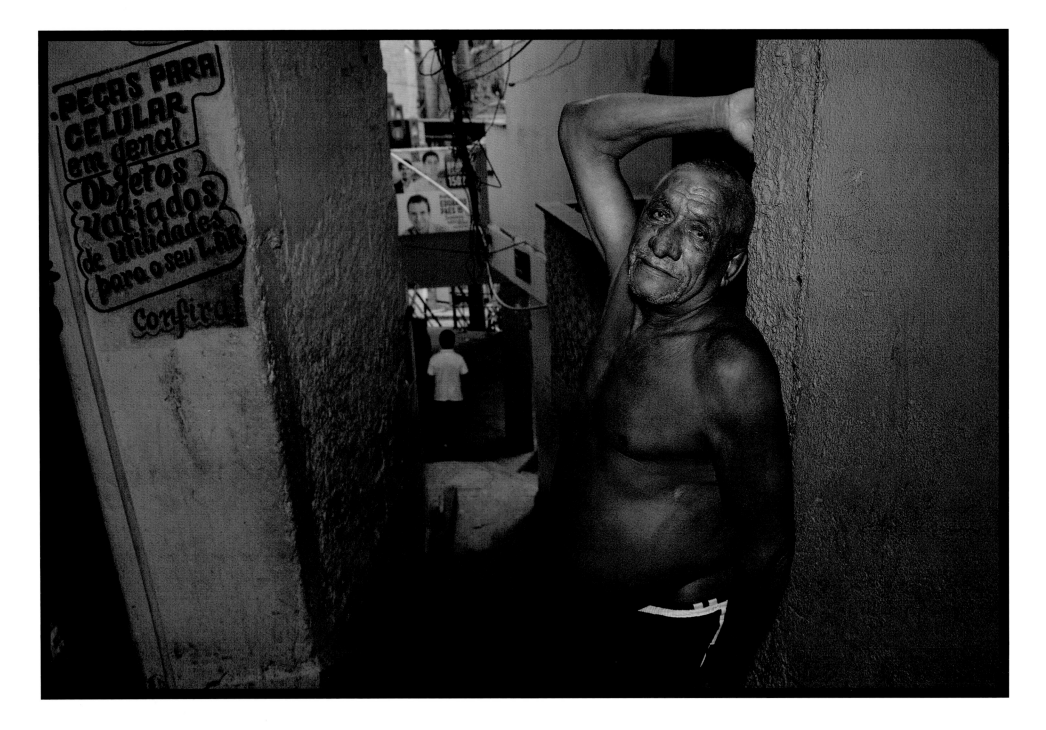

Santa Marta Resident ∫ Rio de Janeiro 2012

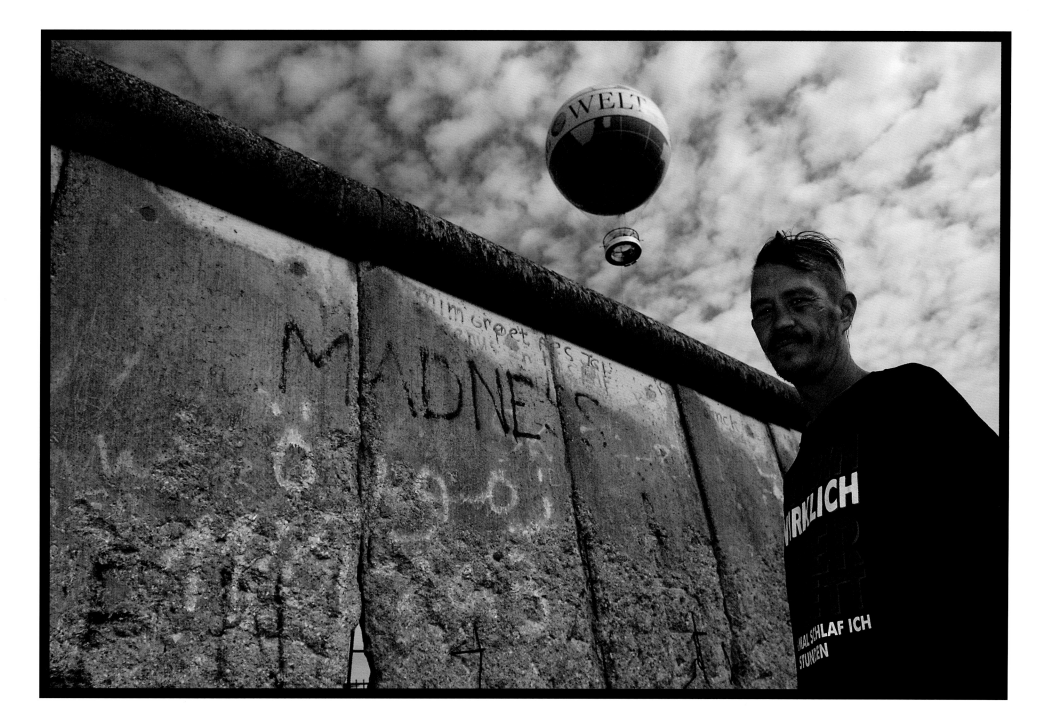

Madness ∫ Berlin 2013

Does eye contact in a documentary or journalistic image break down the authenticity of the subject, or the moment? When a subject looks back into the camera, do they stop being just an object, an anonymous entity in my frame? And does this transition allow the viewer to identify more with the subject, breaking down the conventions of visual interpretation of images that are meant to operate as documents, pieces of reality, visual reporting? Maybe eye contact makes the viewer ask more questions.

In theatre they talk about "breaking the fourth wall," that invisible line separating the actors from the audience. As Tim Raphael, a friend and theatre director, described it in reaction to this work, "*Eye Contact* in photographs reframe the person in relation to the environment. . . . The returned gaze, and the consciousness of being photographed to which it testifies, makes the photographer and viewer complicitous in placing the subject in this environment and framing their identity in relation to the scene the photograph depicts."

Eye Contact is not an idle intellectual exercise but an instinctual reaction for me as a photographer. Having worked throughout the world for over thirty years, often feeling like an intruder repeatedly encountering harsh, suspicious stares, I find myself wondering, am I that threatening or is it just my camera?

Ed Kashi ∫ *VII Photo Agency*

www.edkashi.com

The above statement was excerpted from Ed Kashi's similarly named exhibition, Eye Contact, *at the VII Gallery in Brooklyn in 2011.*

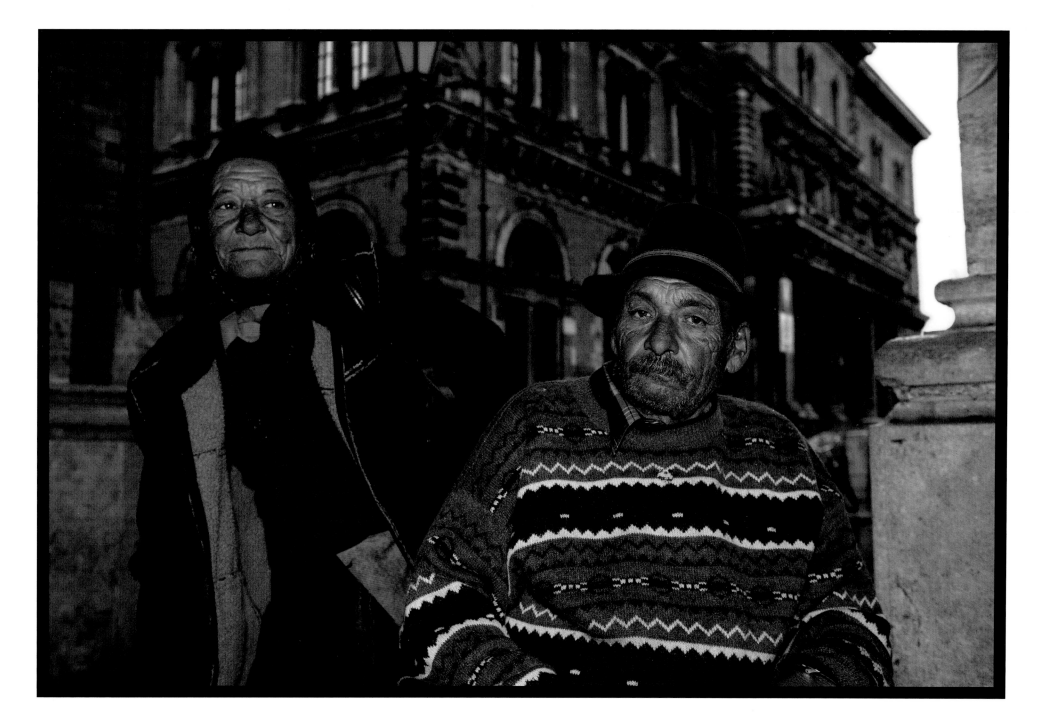

Hungarian Couple § Budapest 2013

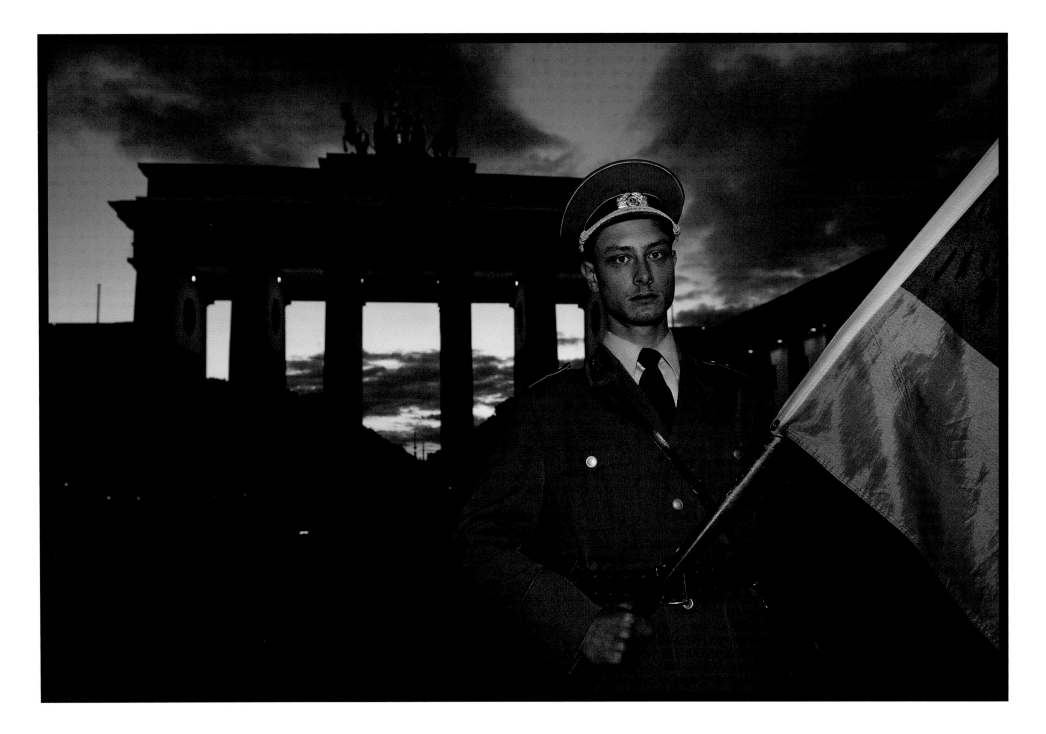

Brandenburg Gate ∫ Berlin 2013

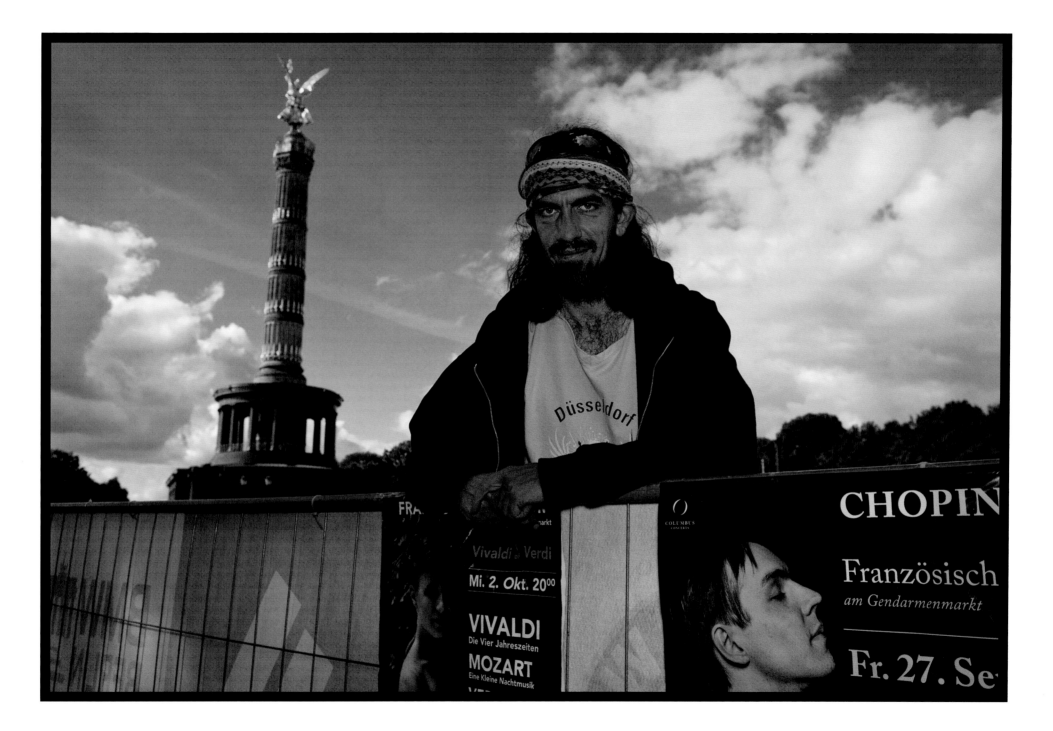

Victory Column, Tiergarten ʃ Berlin 2013

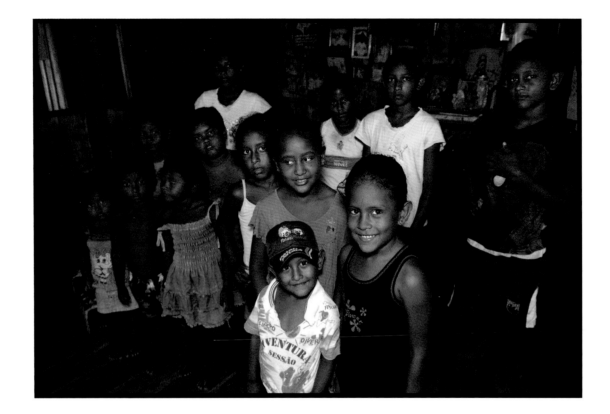

The omnipresence of images. It's an assault on our visual senses—but how do we cut through the visual noise? We live in a world obsessed with images: exploding out of our computer screens, in edgy magazines and gray newspapers, posters at bus stops, brochures in our mail, in museums and galleries, and of course, the latest "breaking news" images from our favorite cable channel. But very few rise to the level of being memorable, mainly because they flash by so fast. They don't really make an impression on our overloaded brains. And how many significant images are being created by us? Sure, we take smartphone photos, post them online, e-mail them to our friends and relatives, or just let them dwell on a hard drive or on the Cloud somewhere. But at the end of the day, what do we have to show for it? Nothing truly permanent that resonates over time on how we really felt about a subject, or the situation we made it in. We just record it, post it, forget about it. It's time you took that camera more seriously: use it to reflect how you feel about the world around you, really look at a subject intensely, don't just document them. We have enough of that already!

Village School Children, Amazônia ∫ Brazil 2012

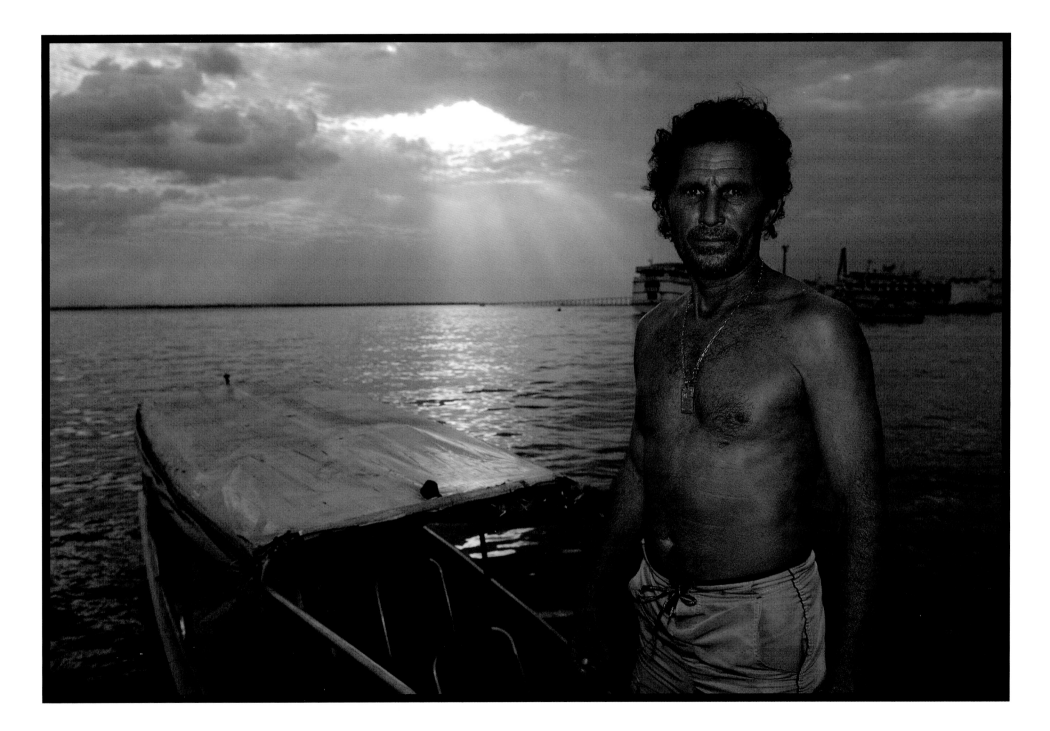

Amazon River Boatman ∫ Brazil 2012

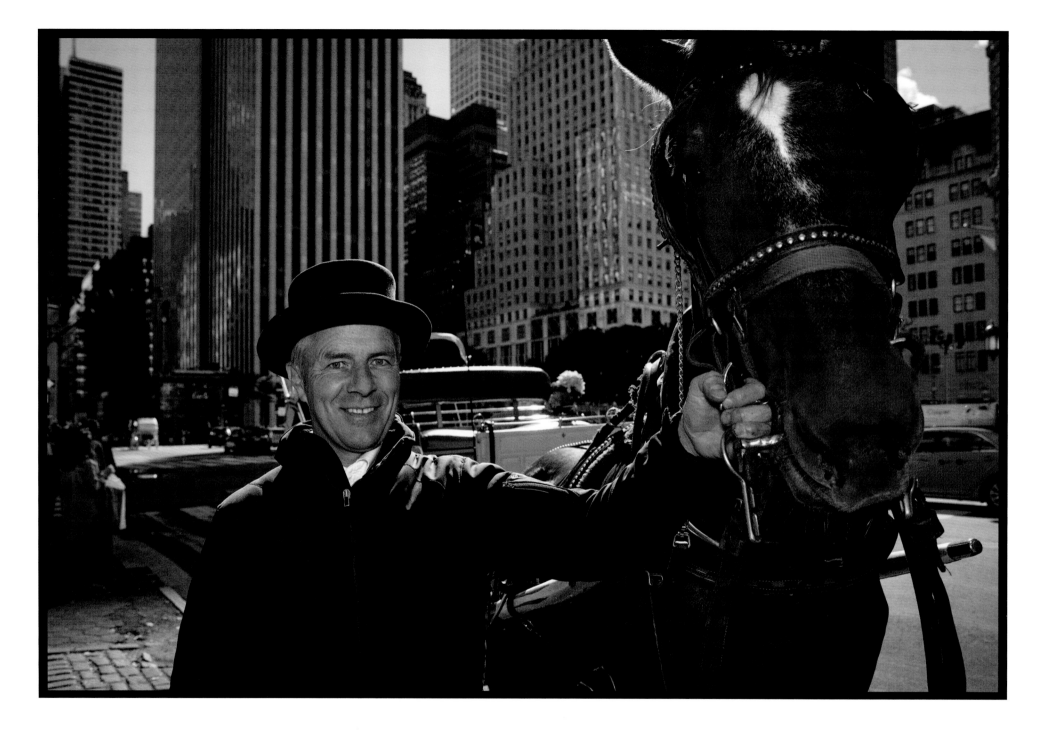

Horse-carriage Driver ʃ New York City 2015

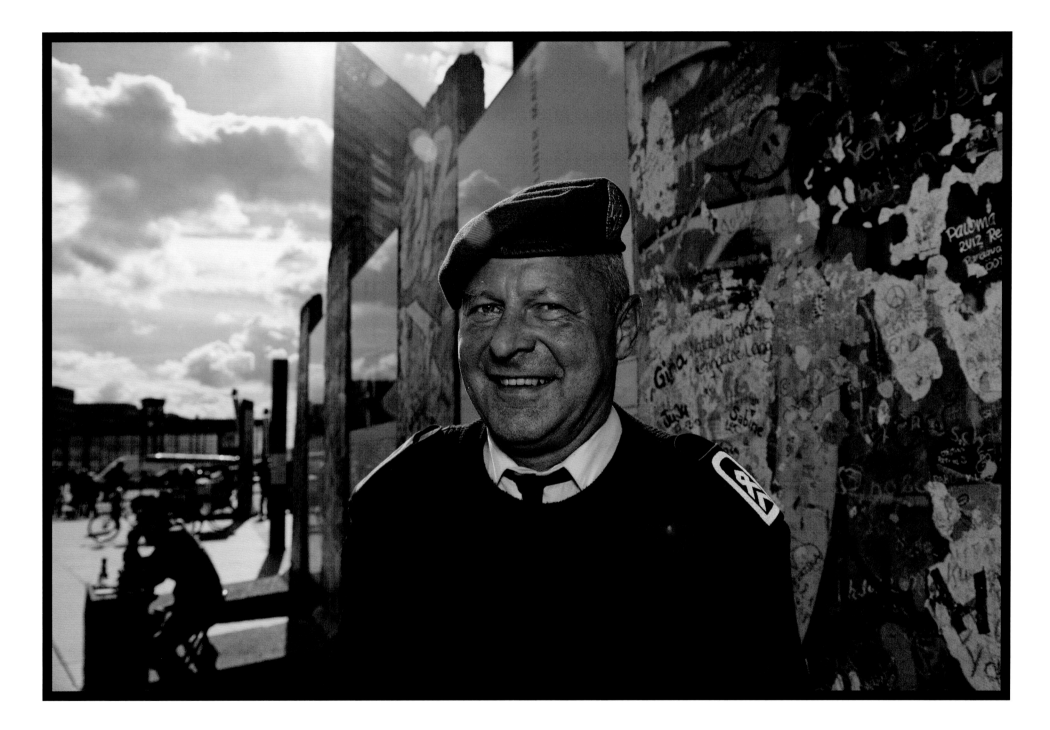

Potsdamer Platz Wall Section ∫ Berlin 2013

"Interested. Respectful."

How to get what you want from strangers? Being nonthreatening, friendly, not necessarily smiley, but pleasant. Interested. Respectful. That's how I try to come off to strangers. Often I don't ask first verbally, but do it with eye contact and body language. Or sometimes with just a greeting in their language while moving into position to get the image I want, assuming they don't object. If they back off, hesitate, act negative, I don't push it. "Sorry to bother you," and if it's too good to pass up a shot: idle chatter, saying anything. Being a little stupid, letting him or her know there is no threat, nothing to fear. Second rejection is it. No three strikes I'm out, two is enough, respect privacy. With digital now, it's easy to show someone who is hesitant the image on the back of the camera and tell them how good it looks, let's take a few more and make a better one. Usually that works. I don't like having my picture taken either, but like most people, I'm a sucker for flattery.

Peter Menzel ∫ *Photographer*
menzelphoto.com

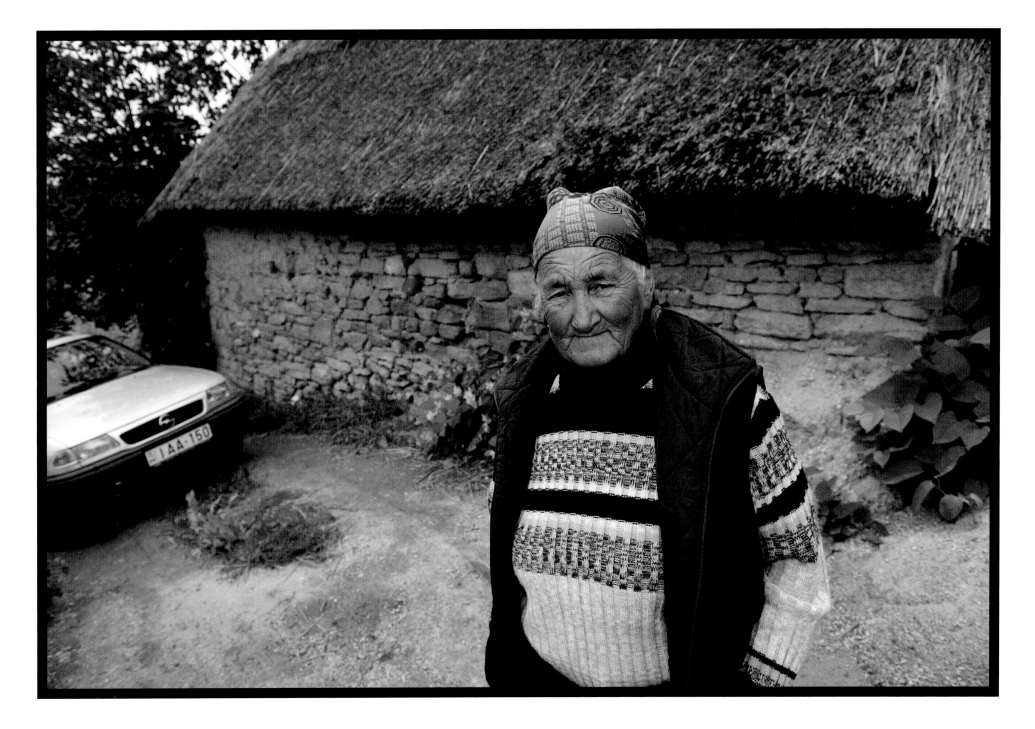

Tihany Resident ʃ Hungary 2014

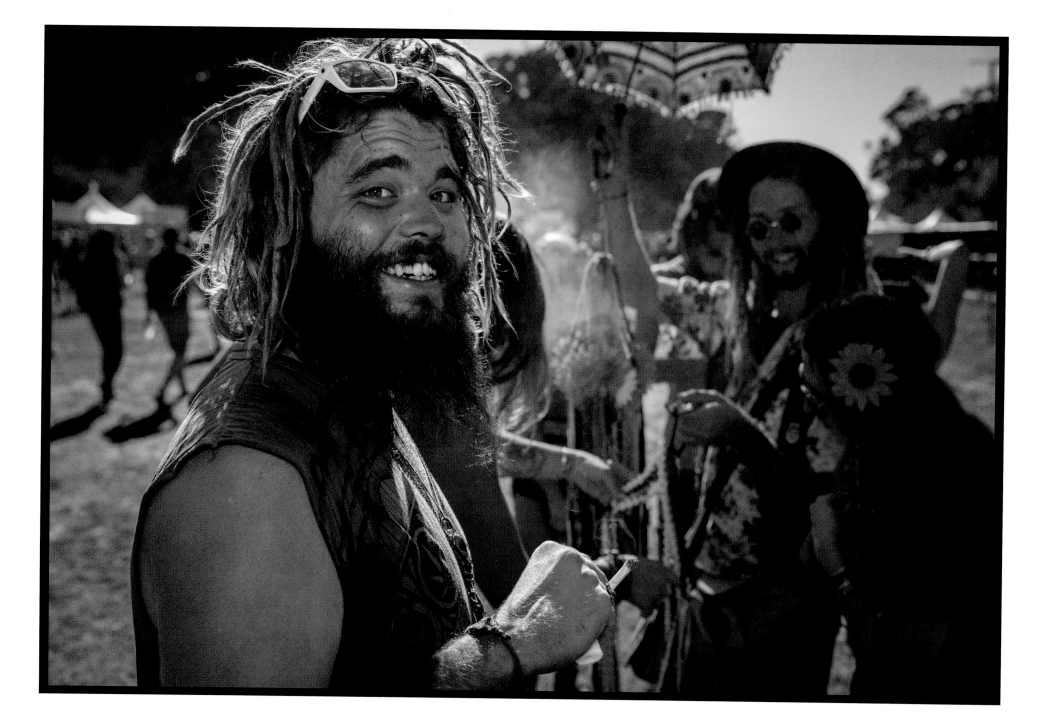

Smoker in Golden Gate Park ∫ San Francisco 2014

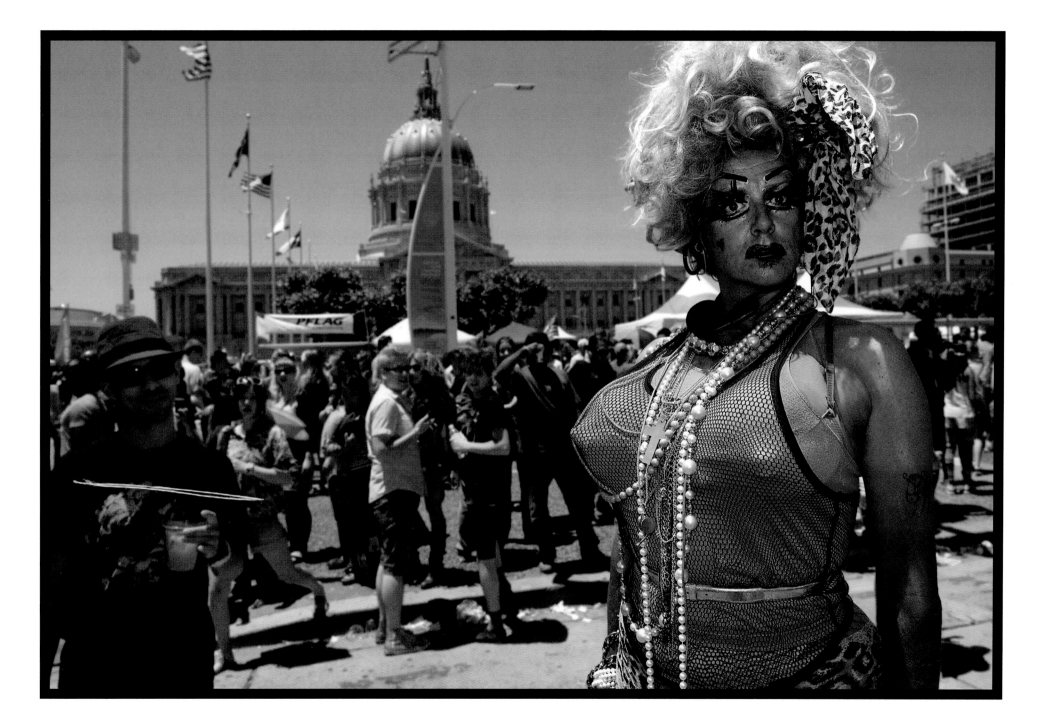

Pride Parade Pose ∫ San Francisco 2011

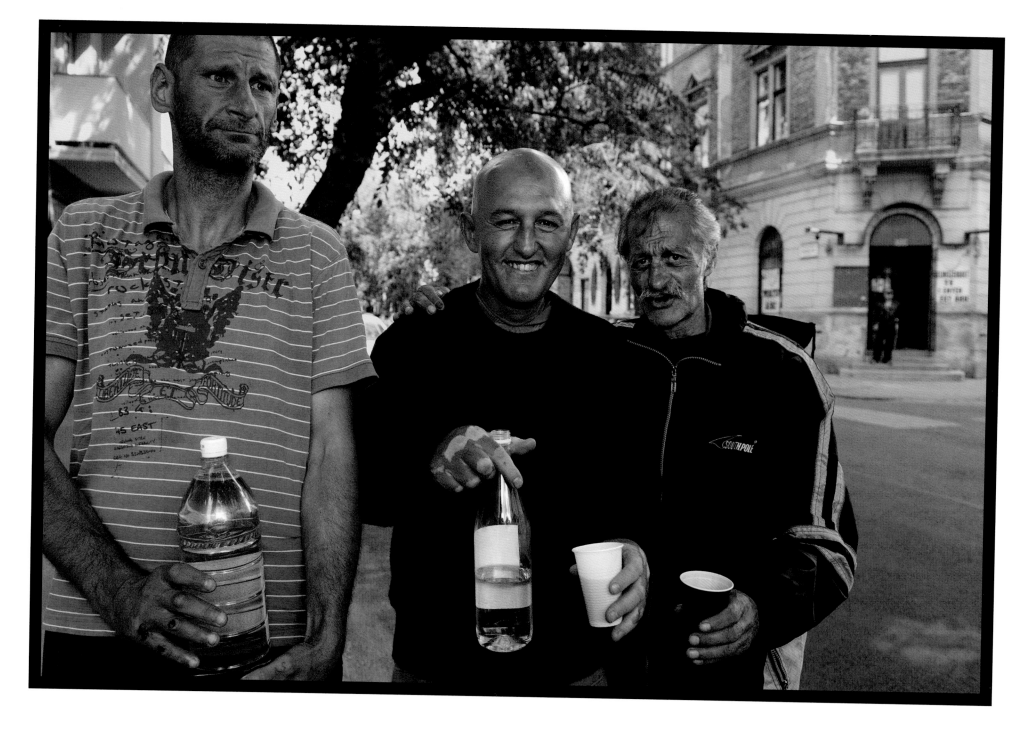

Drifters in District VIII ∫ Budapest 2014

"…was well outside my comfort zone!"

We met these jovial self-described *csöves* (drifters) in District VIII of Budapest, an area made up of an eclectic mix of poor families, the homeless, drug users, and the occasional prostitute, all sharing the narrow streets between neglected old buildings, but also home to a few upscale cafés and trendy galleries frequented by young professionals. Serving as a first time guide/translator/fixer, approaching strangers, chatting them up, and asking if we could photograph them was well outside my comfort zone! But I was pleasantly surprised by the eagerness of this trio to cooperate. What I didn't expect was the rage of the owner of the corner store where they were hanging out, my thinking it was an ideal location for the photograph. I tried my best to explain that his store appearing in the same photograph with them would not destroy his store's reputation, but my argument was no match for his rich collection of Hungarian swear words! So when he started calling for the police, we decided to retreat to the other side of the street. Ironically, if you look in the background, you can still make out the irate owner, which could have been avoided had he just quietly retreated into his store in the first place. But I think our three spirited subjects would continue to patronize his store, nonetheless!

Gyöngyvér Kovács **∫** *Budapest, Hungary*

You need a certain degree of confidence to photograph people, especially strangers. If you can display a cool, in-control demeanor, your subject will be more at ease and will be more willing to partner with you.

Photography is my way of exploring the human condition; it's a medium that speaks a universal language. I'm not the first person to say that, but, from experience, I certainly relate to it.

Champagne Couple ∫ Florida 2011

Google Camera ∫ Half Moon Bay, California 2014

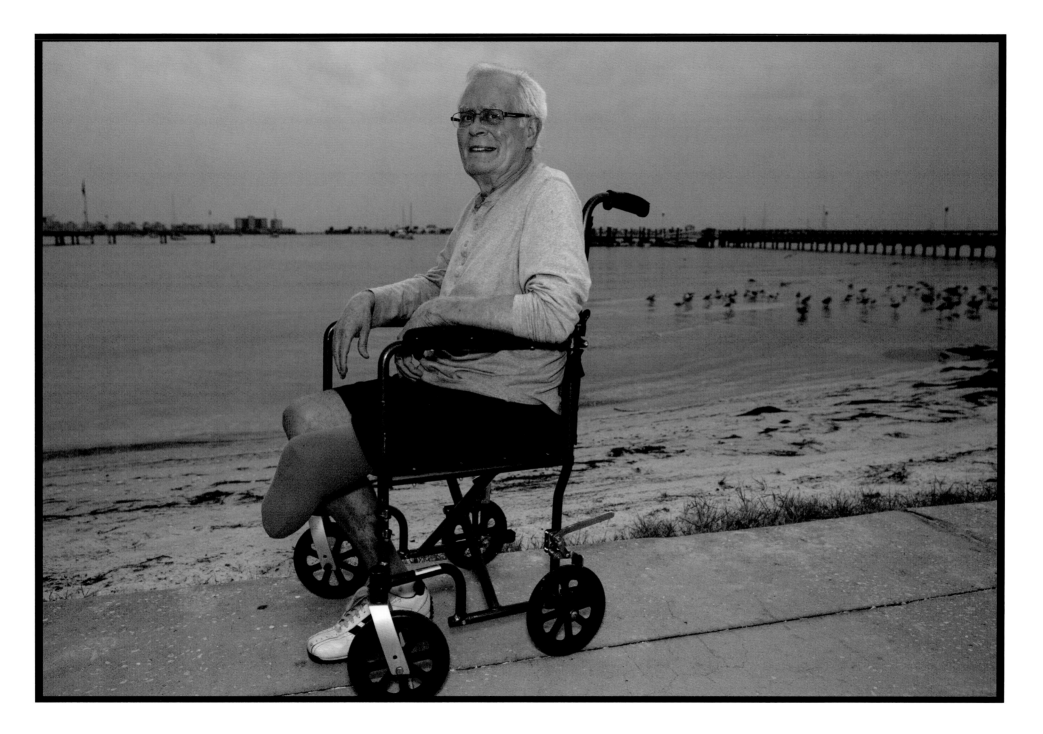

Approaching Storm ʃ Gulfport, Florida 2014

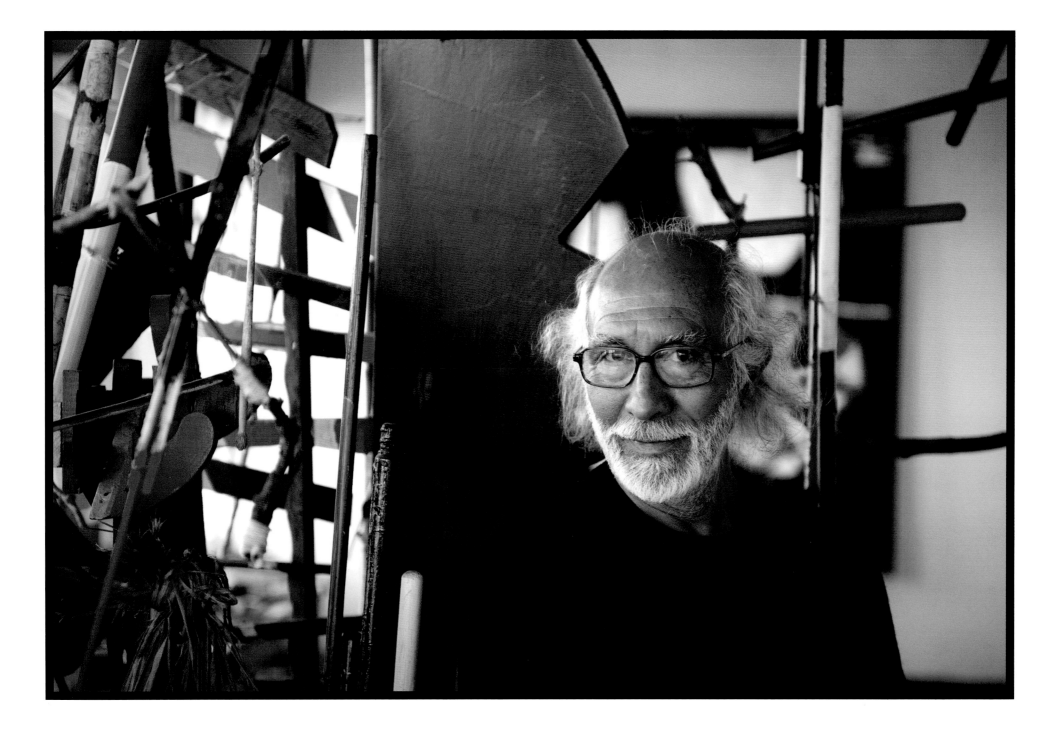

Gustavo Rivera in his Studio ∫ San Francisco 2009

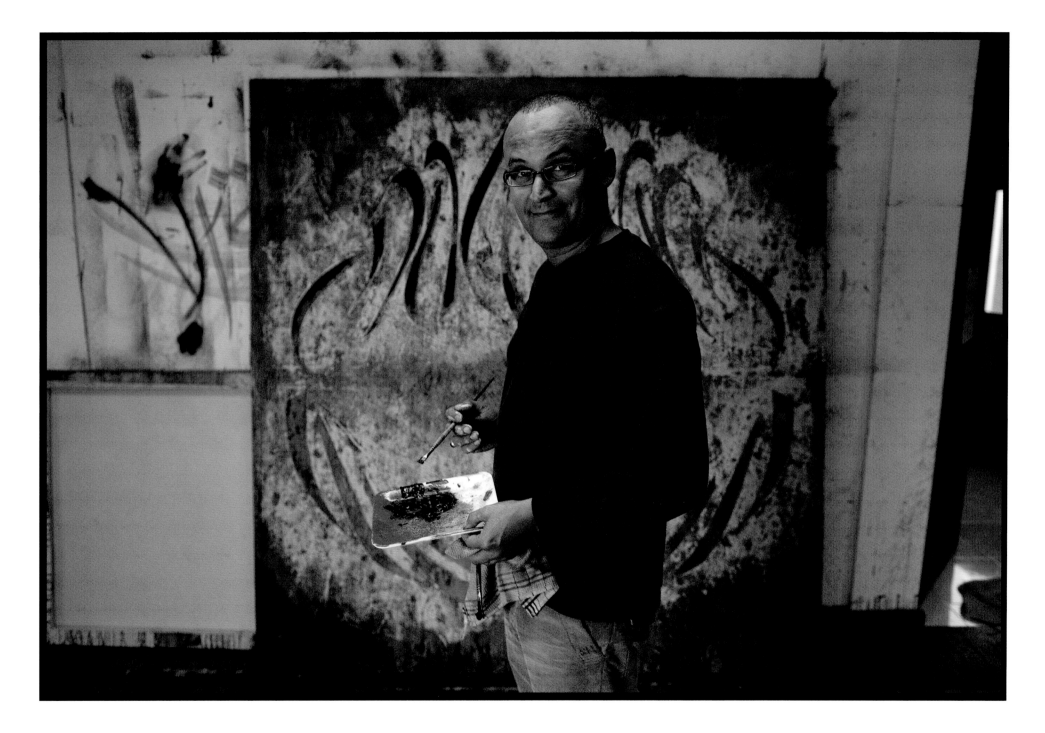

Noureddine Chater in his Studio ſ Marrakech, Morocco 2010

Stuart, how do you relate to the strangers you photograph?

I photograph strangers primarily because nobody that I know enjoys having their portrait taken, and so I headed down the well-trodden path of photographing people I met on the street. I knew straight away that I needed to put people at their ease, and so over time I have formulated a pretty tight script that I stick to religiously. It's then down to the person I am photographing as to whether I go off-message and start talking about other things. I always start off with the statement "I know it's horrible being stopped by a stranger," and then I look wryly at the Hasselblad resting on my shoulder and say "I'm a photographer, which you'd never guess." As soon as I say these two statements I can see the person relax as they know I am not a "chugger" [charity solicitor], and the use of humor lets them know I'm not a threat. Sometimes the image is taken within seconds, and sometimes after I press the shutter they talk with me and I listen to their problems or hear about their passion for art or music or whatever they want to talk about. For me it's all about connecting with people.

Why do you usually have them gaze directly into your lens?

I wish I had an erudite answer to this, but in all honesty it is just learnt behavior, a convention. Just as born-again Christians wave their hands in the air when they are worshiping because when they joined they saw everyone else doing it, I ask people to look directly into the lens because the people I first saw doing deadpan street portraits, like Alec Soth and Joel Sternfeld, tended to have their subjects doing the same thing. However, the more that I am doing this type of photography, the more I am playing, and there are an increasing number of examples in my work of people looking into the distance or concentrating on a task rather than gazing directly at the viewer. So it's evolving.

Stuart Pilkington ∫ *Photographer, Curator, Blogger*
www.stuartpilkington.co.uk

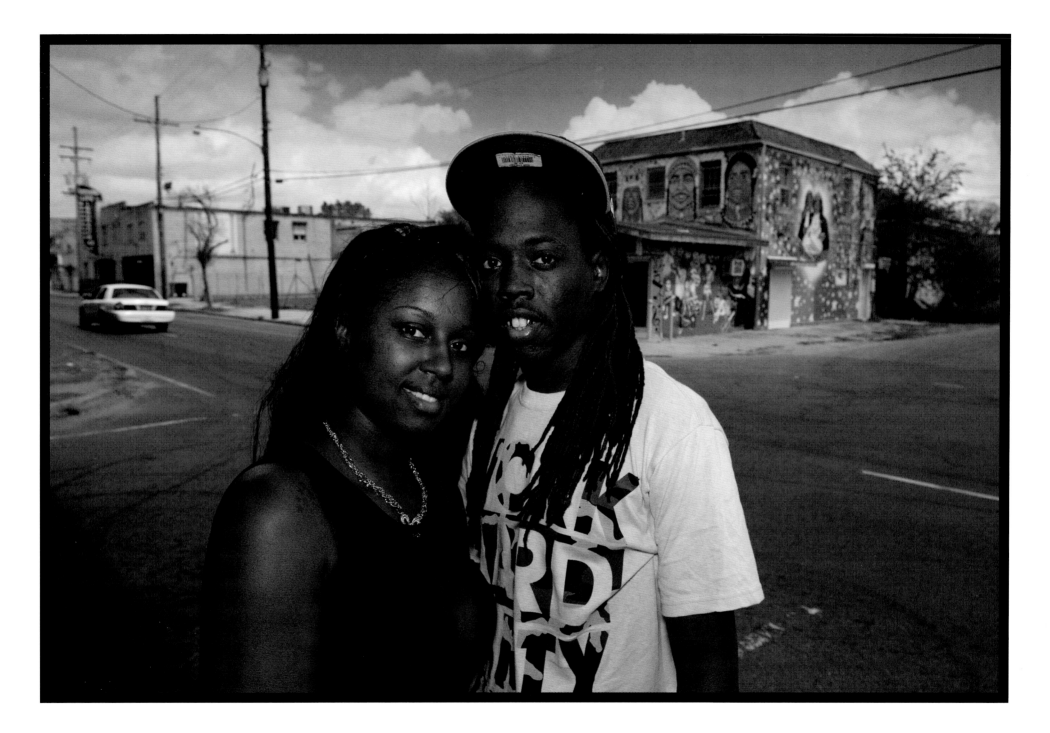

Tremé Neighborhood ʃ New Orleans 2013

A lifetime of travel . . . exploring this diverse earth and its marvelous people . . . it is the essence of what binds us together and enriches our souls.

What is it upsetting two local country women visiting a museum of culture in Bukhara, Uzbekistan? I see them gesticulating, discussing something in the museum they have just seen. It is clearly important to them.

I ask my local guide to ask them what is up? Ahhhh . . . it seems they have spotted a special material on a piece of furniture which would NEVER be used that way; it is actually a bride's wedding day covering. They know that but the museum does not! I let them know how wonderful it is they spotted the error; they are the experts, it seems, in this traditional art form. They respond with delight and laughter; they have a solid, clear sense of themselves within their own history and culture. We warmly hug for a moment in mutual appreciation. They are proud and happy. Then we pose together for a photograph.

I experience again another small truth. I have spent a lifetime exploring the world . . . over 120 countries and counting. I chose to make my life in the travel business after studying history and international relations. My life is enriched each time I explore or return to a country. My fascination with how we as humans have created such multiplicities of living solutions and responses to life remains fresh and open. The depth and variety of what we humans do in the world is endless. Meeting people—connecting with them in such varied circumstance—that is a powerful connection. It is that very human way we have—if we strip away all the differences, responding to and respecting how each of us has our own ways of being—the core of our experience of life can only be enhanced and deepened.

We get one chance to live our lives well; we need to remember to explore the endless opportunities. It keeps life vital and alive.

Helen E. Land ∫ *International Travel Specialist CASTO VACATIONS San Francisco*

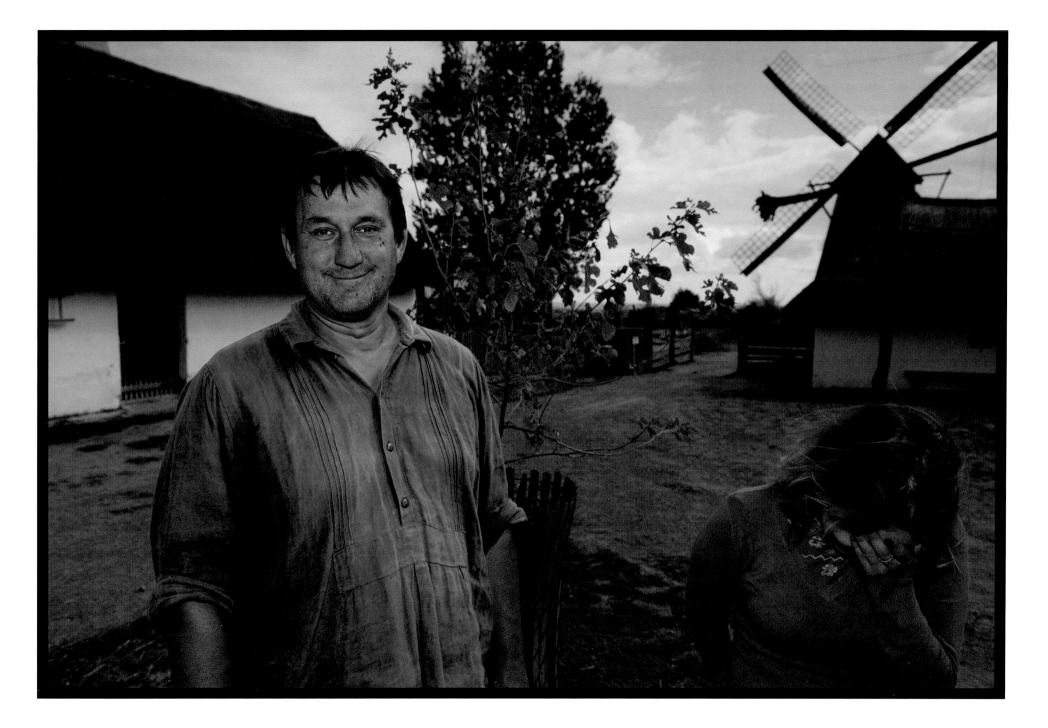

Smiling Farmer ∫ Hungary 2014

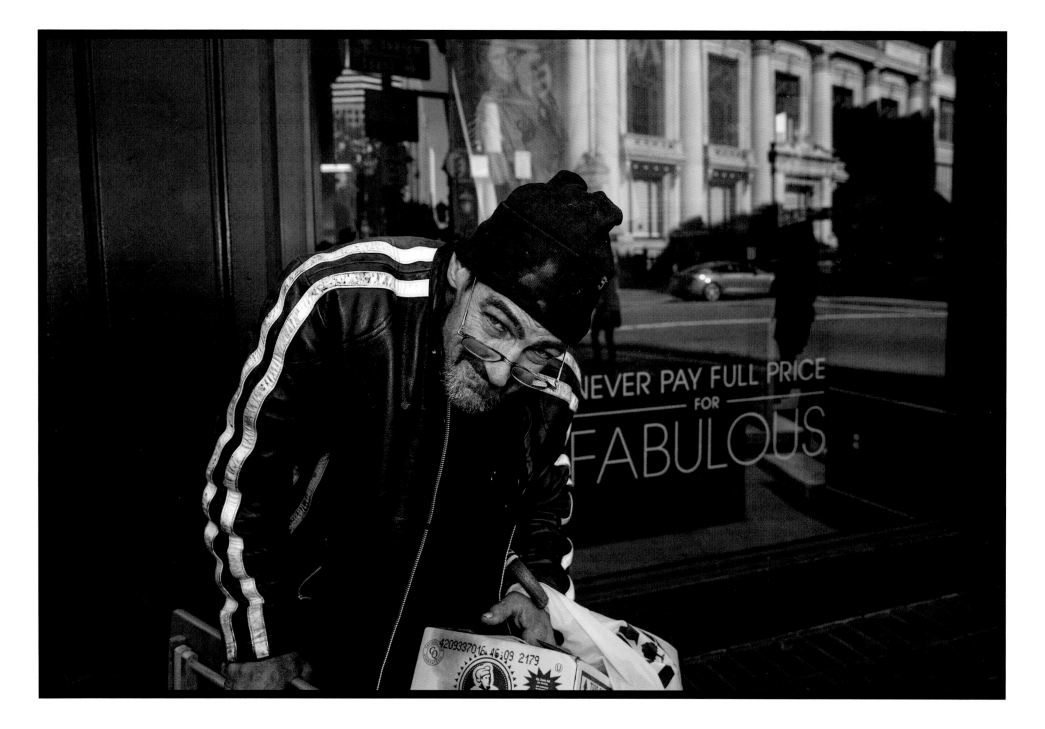

Not Fabulous ∫ San Francisco 2014

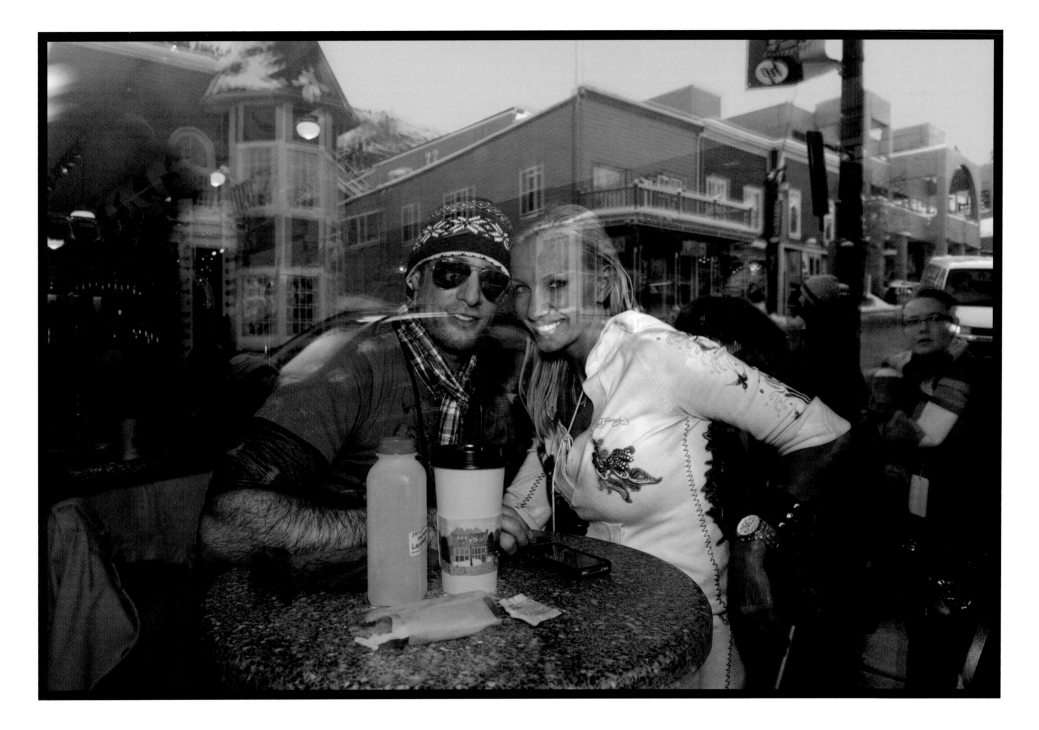

Sundance Couple ſ Park City, Utah 2012

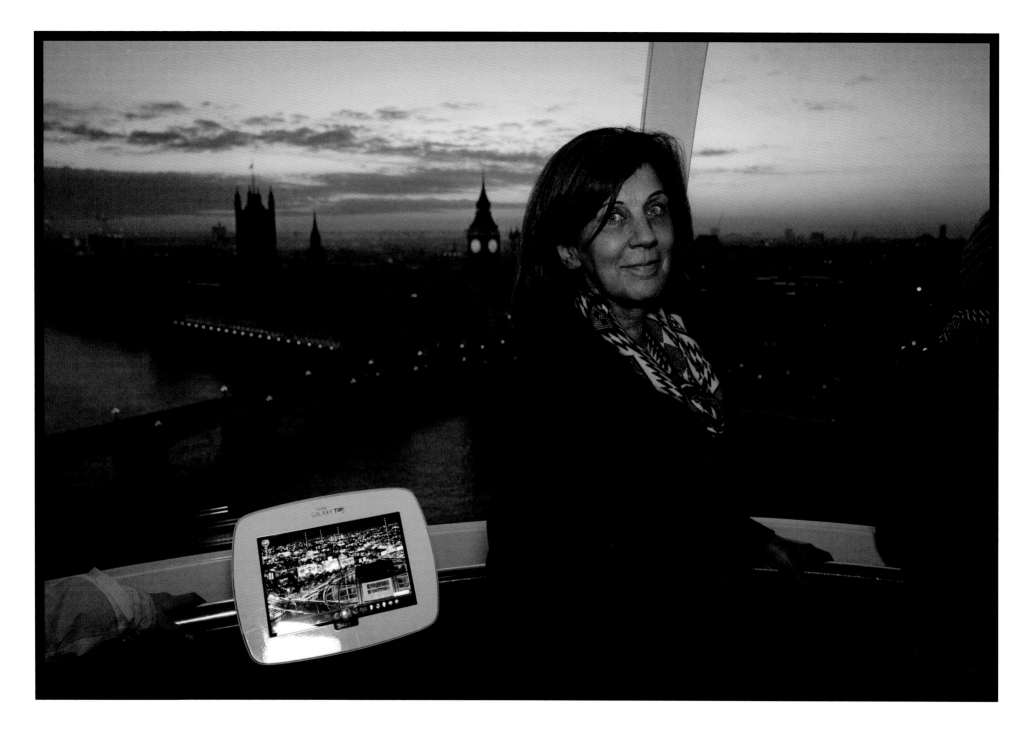

London Eye ∫ London 2014

"Great portraits are sometimes just dumb luck."

But . . . Great portraits share certain fundamentals: a profound understanding of light, pose, and composition.

Great portraits have power when they move the viewer emotionally. Very hard to achieve.

Great portraits require the *subject* to let the photographer in. Years to understand how that dynamic works.

Great portraits. Eye contact? For me, absolutely.

Timothy Greenfield-Sanders ∫ *Photographer/Director New York*
www.greenfield-sanders.com Instagram: tgsfilm

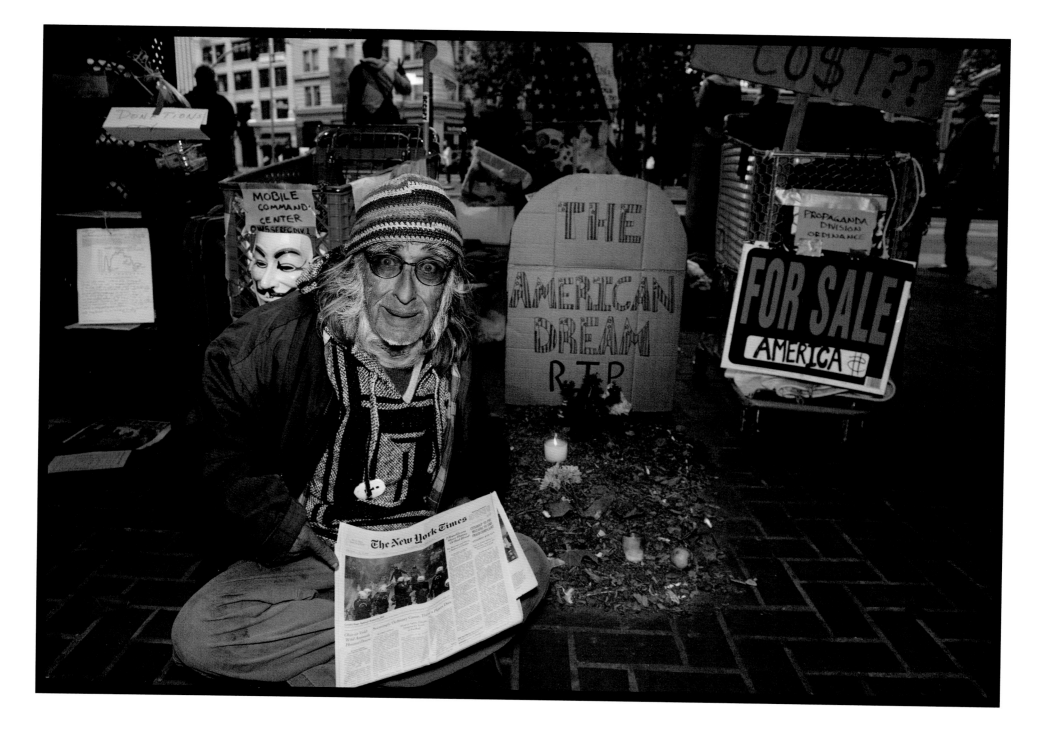

Occupy Protestor ∫ San Francisco 2011

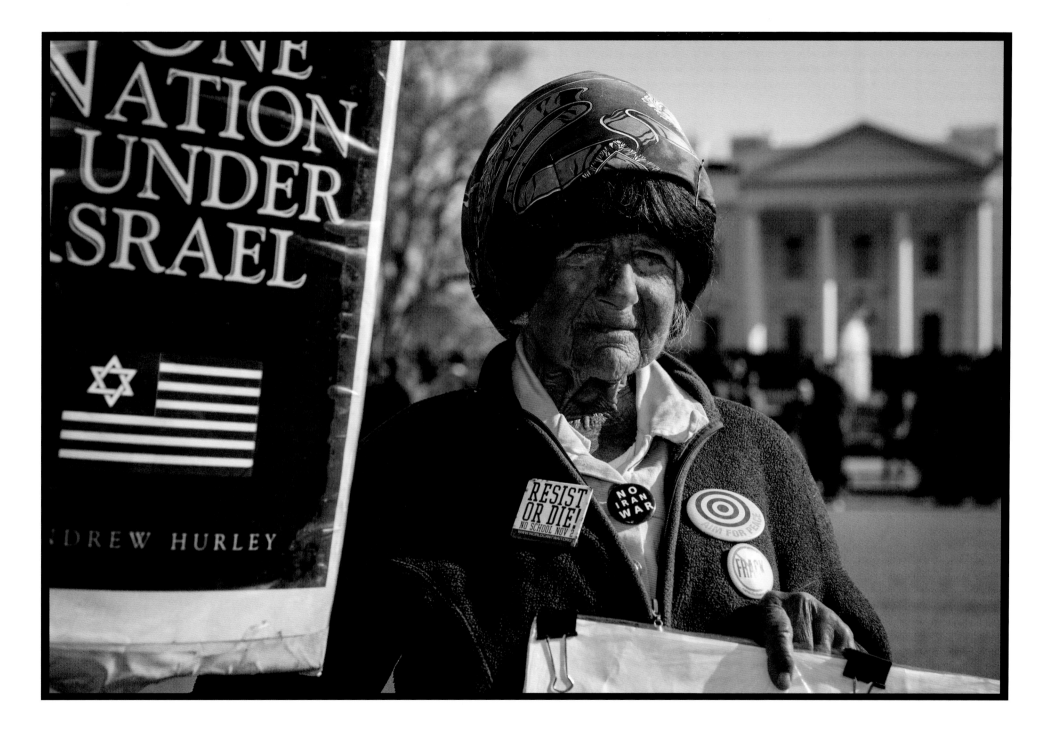

Protesting Since 1981 ∫ Washington, DC 2015

"His subjects display a joyful and trusting attitude…"

While being now an abstract painter and once a landscape photographer, I know the importance of the artist establishing a deep connection with their subject. What is striking about Max's photographs is how he establishes this connection so quickly with total strangers, regardless of their culture, nationality, status, race, or circumstance. His subjects display a joyful and trusting attitude, proud of their appearance, dress, and environment, and what that says about them and how they live. Max seems to convey his acceptance of their humanity and his interest in who they are personally, and his subjects give back an openness and pride in return. His gift to us all is that we experience the humanity that is in everyone, regardless of outer appearance.

Scott Lowry ∫ *Artist*
www.scottlowryfineart.com

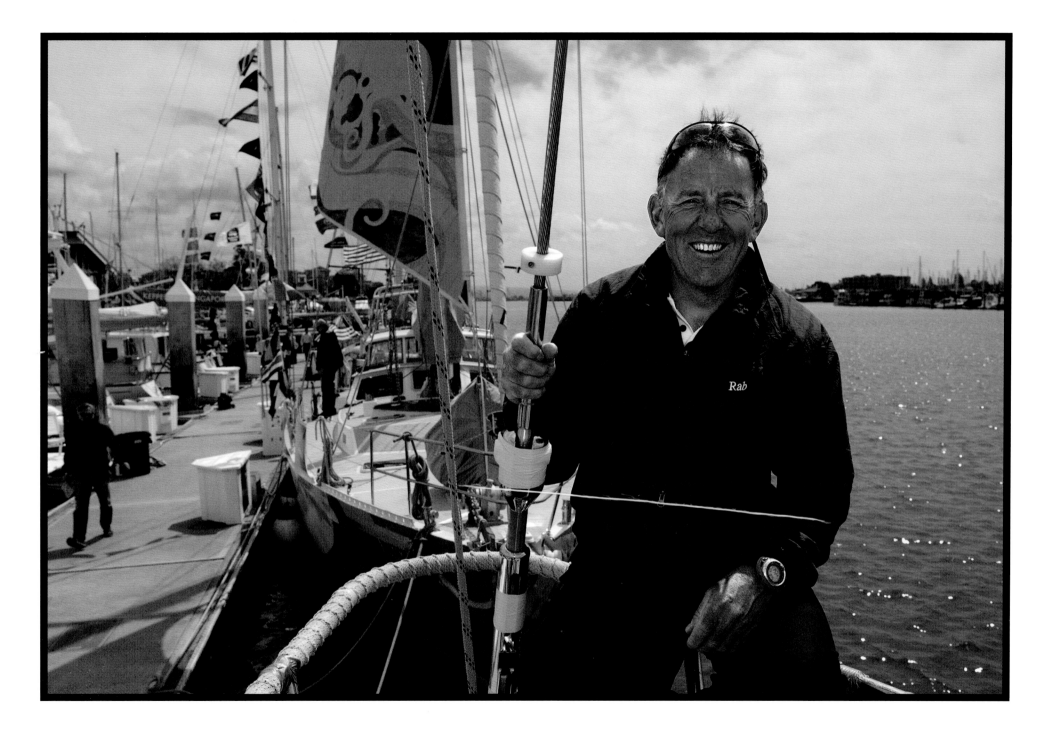

Round the World Sailor ∫ Oakland, CA 2012

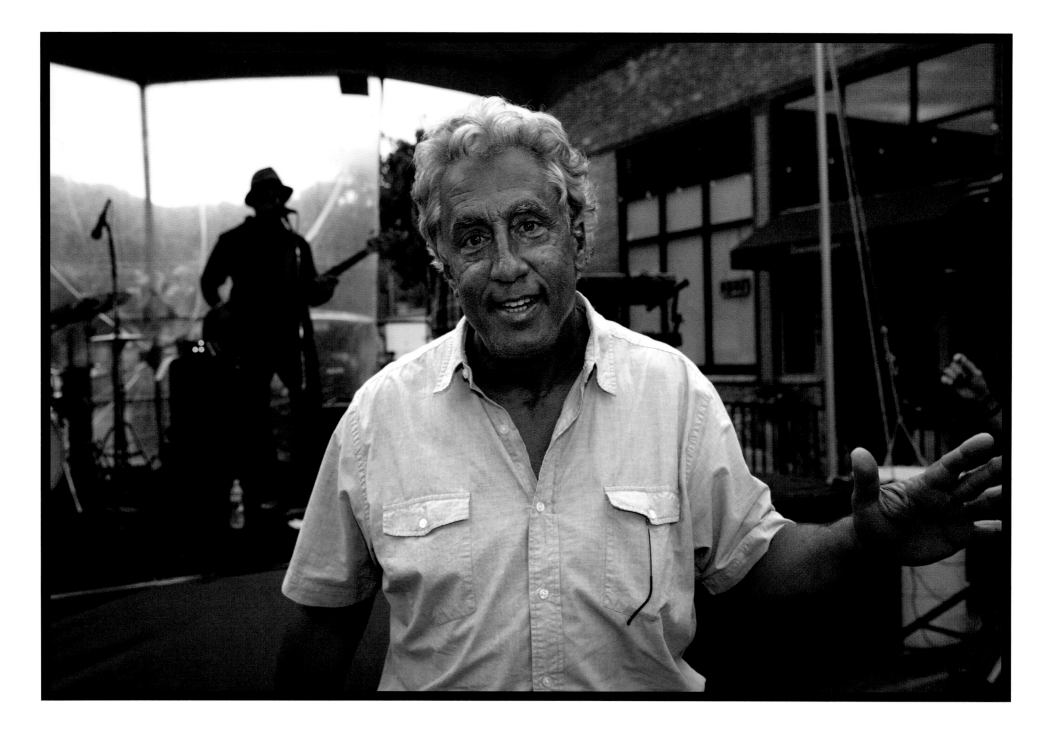

Blues Festival ∫ Northern Californian 2014

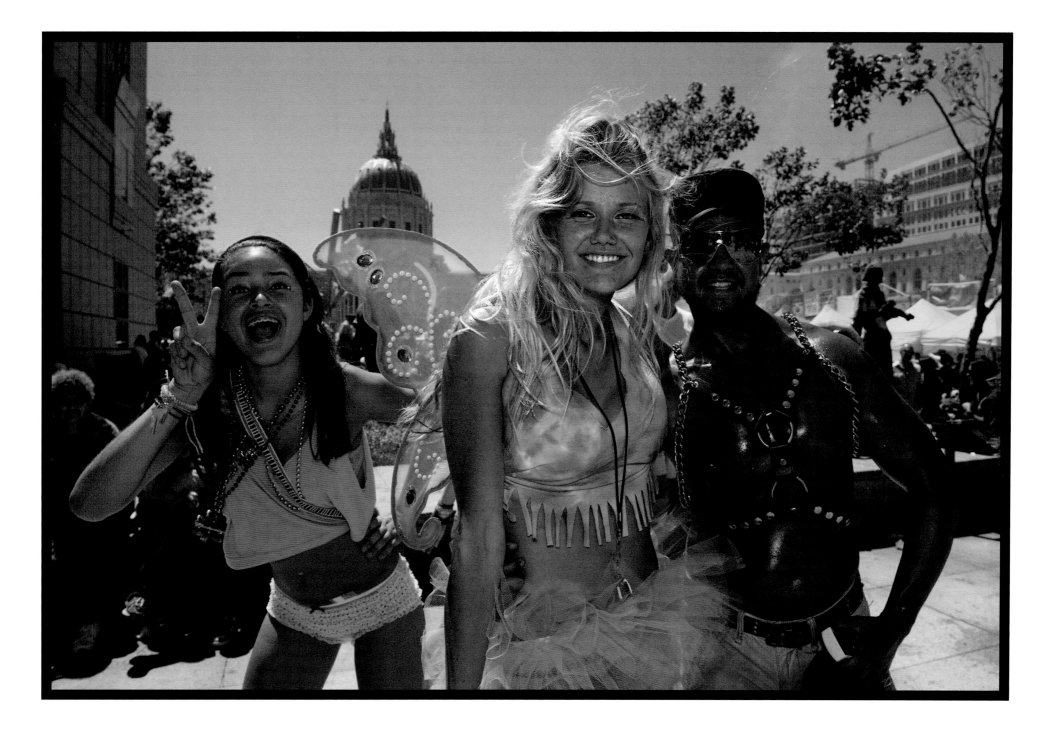

Pride Parade Costumes ∫ San Francisco 2011

Photography fuels my good fortune to have been graced with a visual curiosity that respects people and allows them to own their space in the world. Seeking authenticity in the act of photographing people is paramount and gives one a chance to celebrate commonality. Though the tools of the craft are the same each time, every shot is different, every picture is new. Working in a visual medium that is about reductivism in the face of clutter and about problem-solving in the face of chaos, I get to do something that most can only dream about.

Max Hirshfeld ∫ *Photographer*
www.maxpix.com

Romney Headquarters ʃ Knoxville, TN 2012

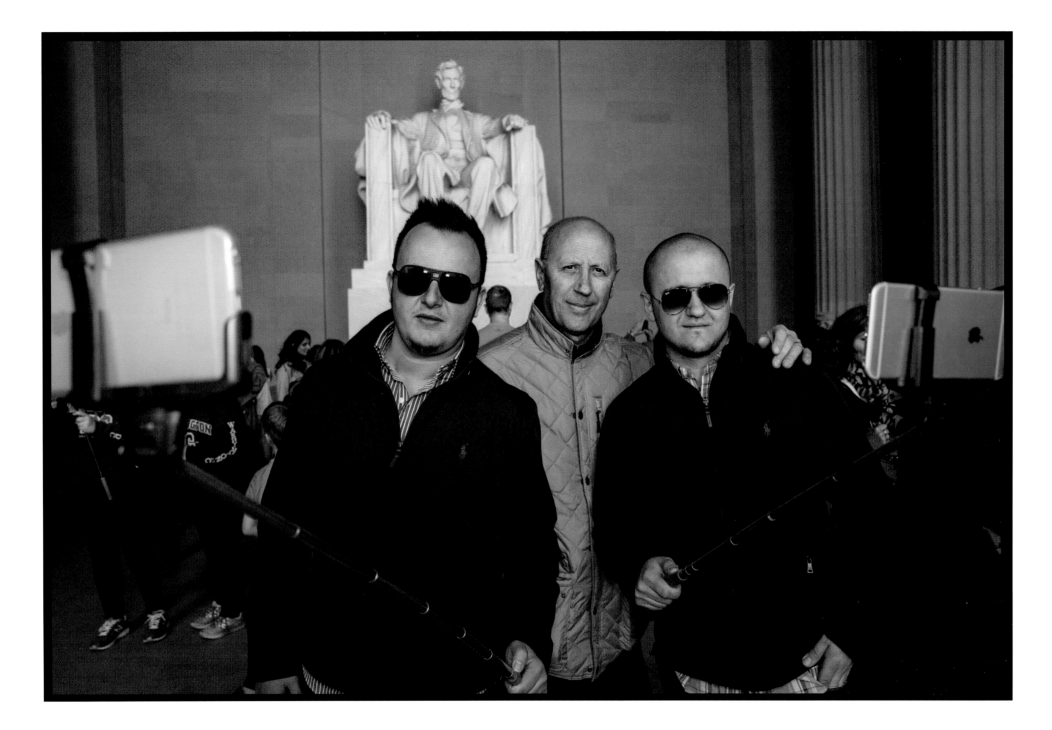

Albanians at Lincoln Memorial ∫ Washington, DC 2015

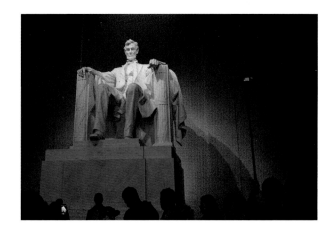

"I don't know you, but I know you."

The eyes are the window to the soul, for sure, but they also offer a pretty good view of the social world. Avoiding people's eyes is sometimes crucial for keeping a delicate social arrangement from falling apart. On the bus, for instance, we obey the norm that the sociologist Erving Goffman called "civil inattention," in which strangers share space without getting in each other's business, allowing each other a measure of privacy in public. Eschewing extended eye contact is a crucial way people maintain that kind of social distance. A person who tries to meet another bus rider's eyes for too long risks being labeled rude or crazy. What are you staring at? What do you want? What's wrong with you? I teach my kids to meet people's eyes as a sign of respect and connection, but avoiding eye contact is also a common expression of deference, and in some situations simply meeting someone's eyes can be a means of defiance and a source of conflict. Who do you think you are?

On the flip side, people often selectively use extended eye contact to connect with some folks while keeping others out of the loop. For instance, there's eye-contact-as-identity-affirmation. A little extra eye contact between passing strangers, maybe accompanied by a head nod or a smile, indicates recognition of shared group membership. I don't know you, but I know you. And I know that you know that I know. Then there's eye-contact-as-announcement-of-sexual-availability, a well-established though perhaps fading code among gay men and assorted others. A slight mutual extension of eye contact, just brief enough that it's undetectable to others, can essentially be the green light to a casual encounter. I'll be waiting for you down the street. Mess up one of these nuanced uses of eye contact, or mix them up with each other, and the results can range from confusion to violence.

Joshua Gamson ∫ *Professor of Sociology at the University of San Francisco*
Author of many articles and books including, most recently,
Modern Families: Stories of Extraordinary Journeys to Kinship

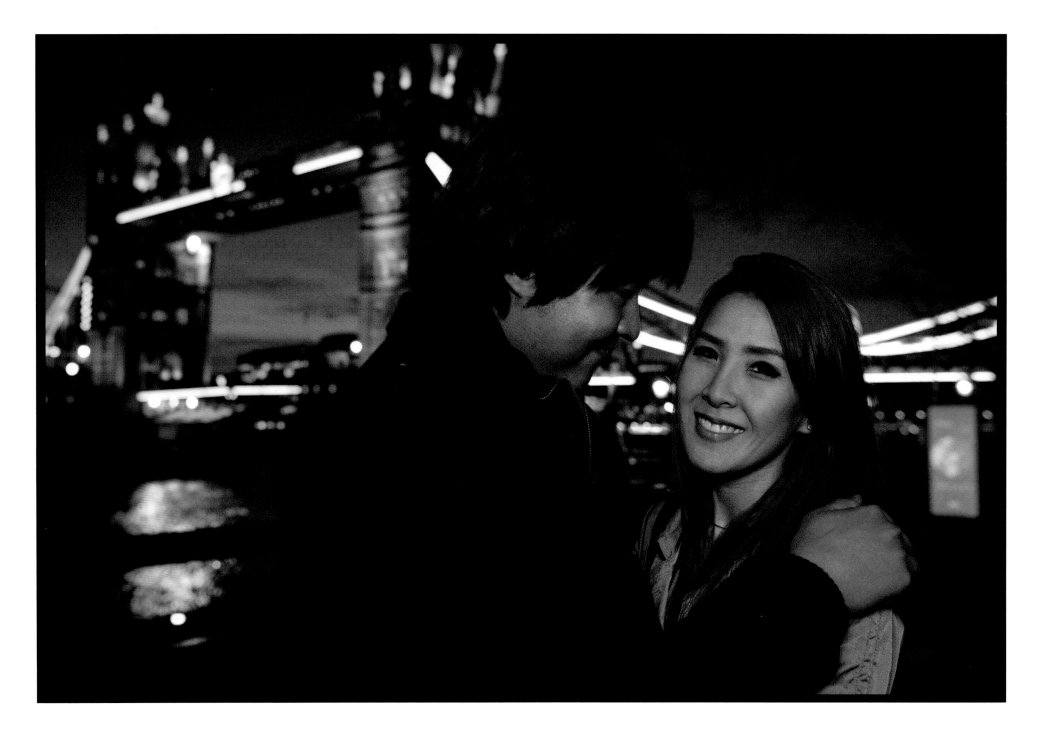

Tower Bridge Couple ʃ London 2015

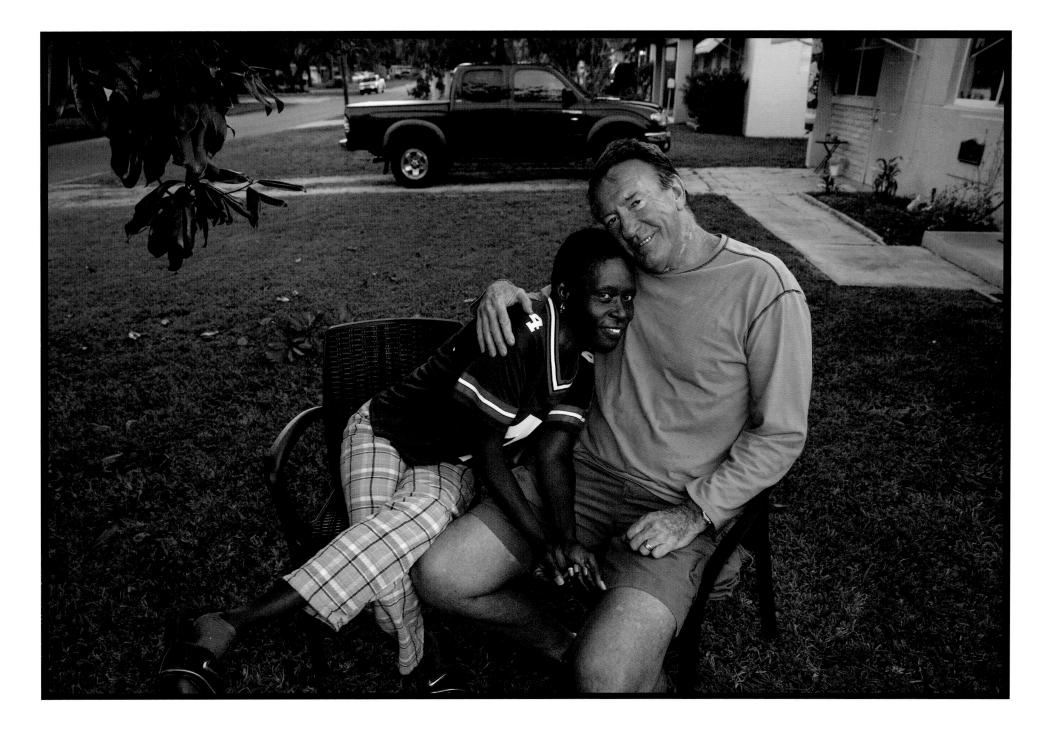

Relaxed Pose ∫ Florida 2014

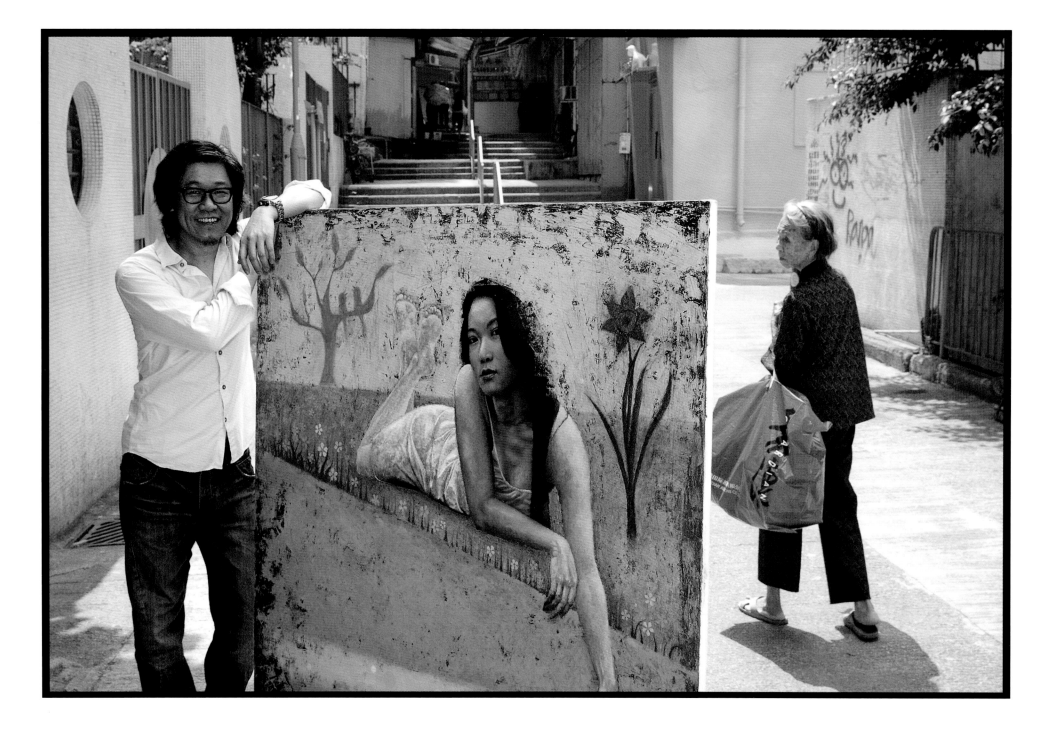

Tom Lau's Painting 𝕵 Hong Kong 2010

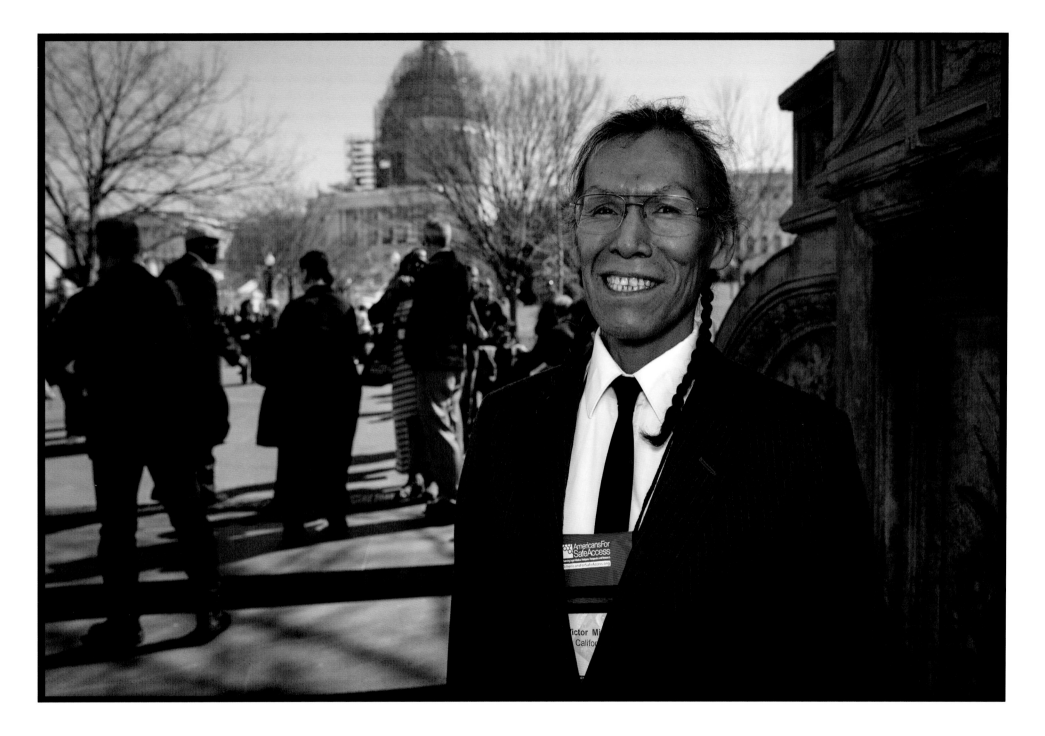

Capitol Hill ∫ Washington, DC 2015

"The guards are sleeping; if they do wake up, they won't see us in the fog!"

I wanted to photograph the Taj Mahal from this side, just as the sun was rising, and that wasn't going to happen if I waited for the 8:00 a.m. official opening. What to do? In talking with some locals the day before, just outside the Taj grounds, I found this man who promised to get me in the following morning. And he turned out to be an intriguing subject, as well. We met up under a dim streetlamp next to his home at 5:00 a.m., said hello to his children, who seemed quite excited by my presence, then set off to locate his "secret" way in! Unfortunately, the narrow entrance, off a dirt street, had an Army guard post! But, fortunately, the two soldiers were sleeping in their chairs, with their rifles across their laps. Hmmm. Go around them, or call it off? My intrepid guide/subject and I quietly stepped around them and headed for the decorative marble walkway behind the Taj, which was shrouded in heavy fog from the Yamuna River.

A few photos there, but I wanted to move down for a lower angle by the river to catch the sunrise behind the mosque next to it.

I managed to get off a few shots by the river, but the guards apparently had been roused and must have seen my flash through the fog. When my subject suddenly disappeared from my viewfinder, I turned to see them approaching, but it was too late to beat a hasty retreat into the fog like he had. They roughly escorted me to a nearby guard hut where I got loudly lectured by a stern sergeant who ordered me never to return, in very animated Hindi. They escorted me toward a distant exit but left me on my own before we reached it. I noticed another path that I thought might lead back towards the Taj, so I took it. My guide had been watching for me, so as I made my way along a wall, he waved to me from the next level up to join him there. We spent the next hour on our own, marveling at the early light as it made this historic monument to love glow golden as the fog burned off. But I still liked the shots down by the river best, with only one minaret of the Taj included on the edge of the frame. If the drowsy soldiers hadn't disturbed us, I might have captured more of it!

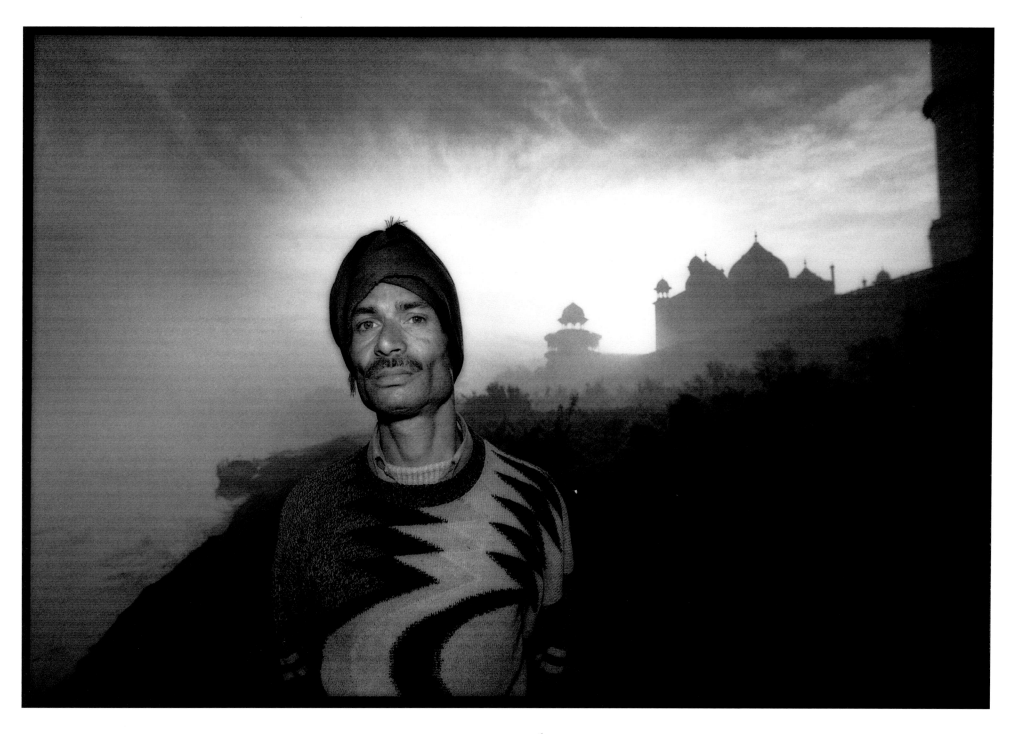

Sunrise Behind the Taj Mahal ∫ India 1998

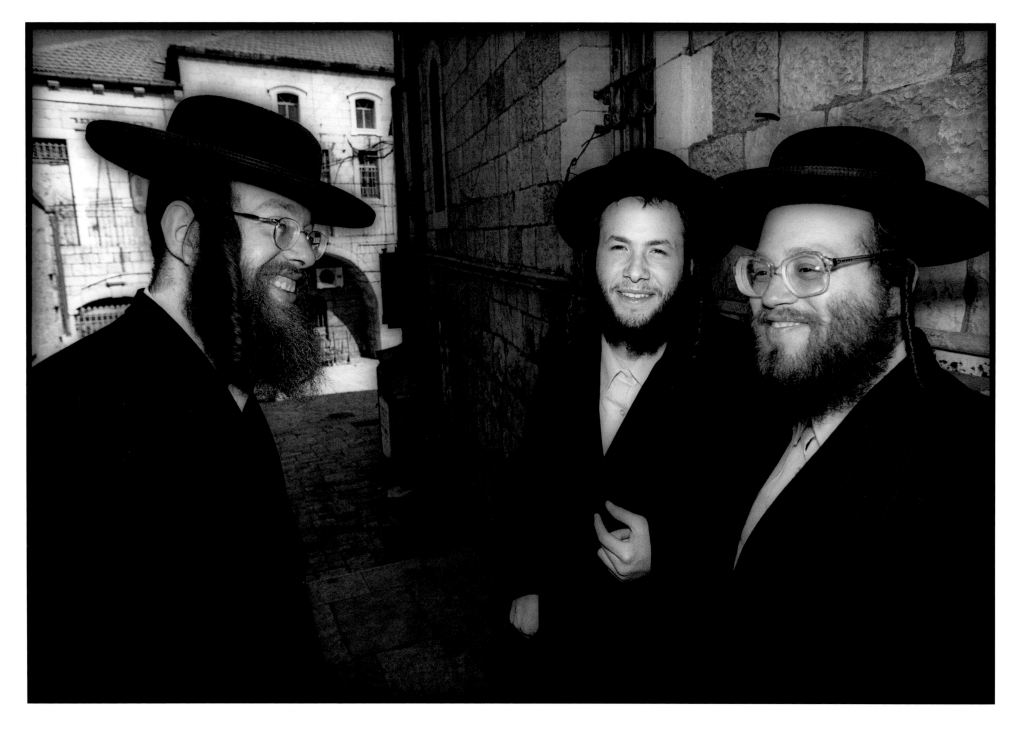

Mea Shearim ʃ Jerusalem 1999

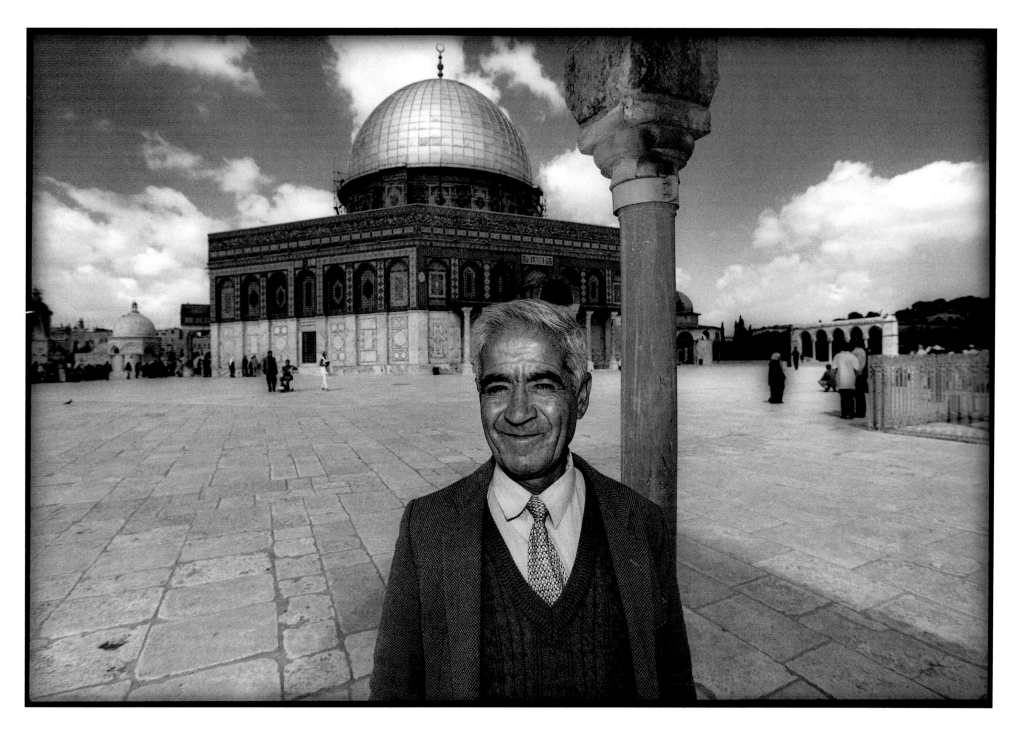

Haram al-Sharif 𝕵 Jerusalem 1999

"…a chance encounter with a circus, camera in hand."

On a beautiful, sunny summer day in 2012, I was walking in the Rose Garden in Portland's Forest Park when I came across a troupe called the Wanderlust Circus. They were performing on a small stage and I happened to have my camera with me. I noticed that the performers were gathering and getting ready behind a group of trees. I went behind the stage and asked the performers if I could take some pictures. They were not only okay with an anonymous photographer photographing them, therefore gaining some free publicity, it seemed having pictures made of them was part of their job description.

I made 160 frames on black-and-white Tri-X medium-format film. I think since the pictures were made during the day, none of the pictures came out particularly well. But after that day, as I sensed that I may have stumbled across a new series of photographs, I made a point of becoming friendly with the MC. He subsequently connected me with all the performers in the circus and one by one I began to make nighttime portraits of them. Meeting the circus performers also helped me meet other nighttime performers involved in different segments of entertainment. I have spent the last few years also photographing burlesque performers, strippers, drag queens, clowns, cos-players, and neo-vaudevillians. None of these pictures would have happened were it not for a chance encounter with a circus, camera in hand.

Jason Langer ∫ *Photographer*
Books: Jason Langer: Twenty Years, Possession, Secret City
www.jasonlanger.com

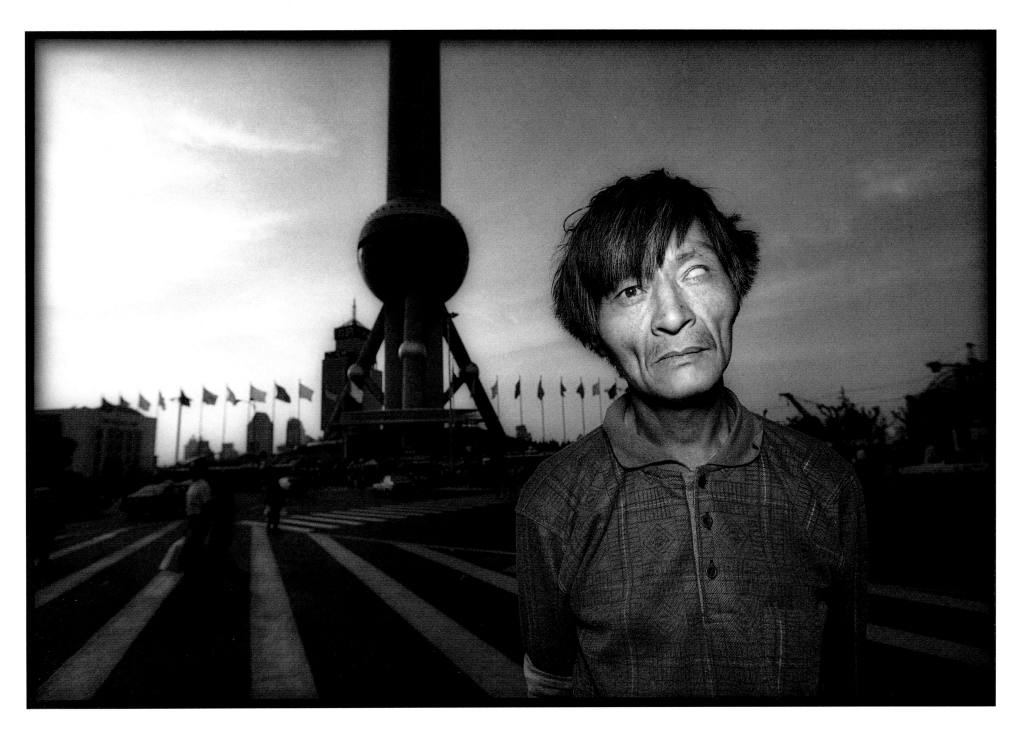

Man in Pudong ʃ China 2000

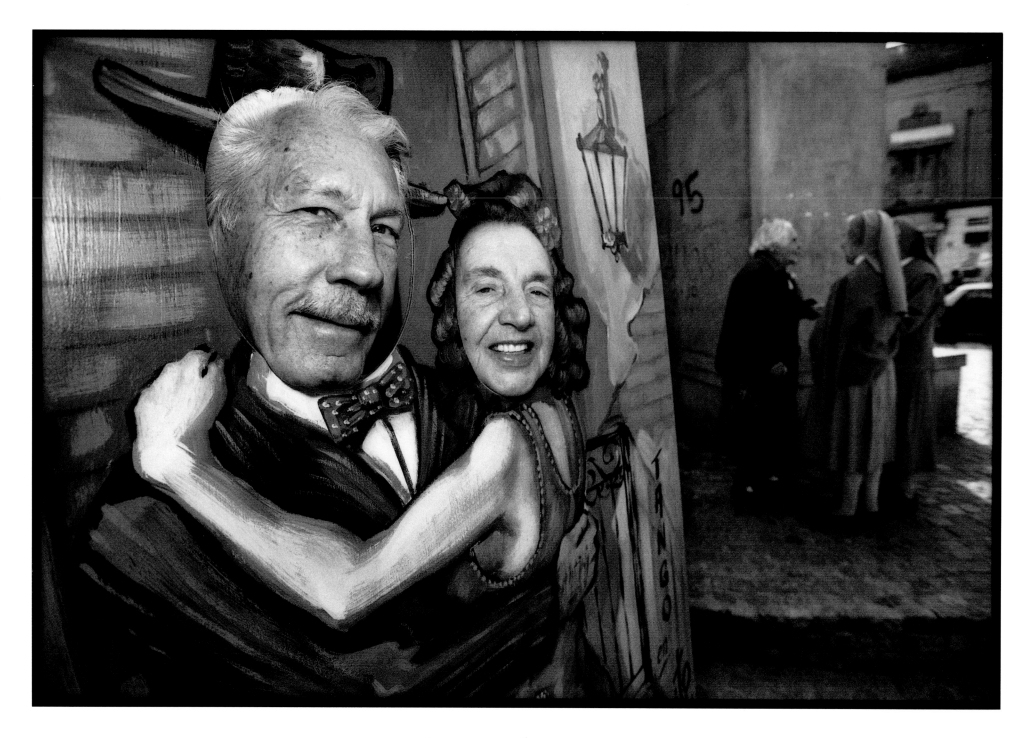

La Boca, Buenos Aires ∫ Argentina 1998

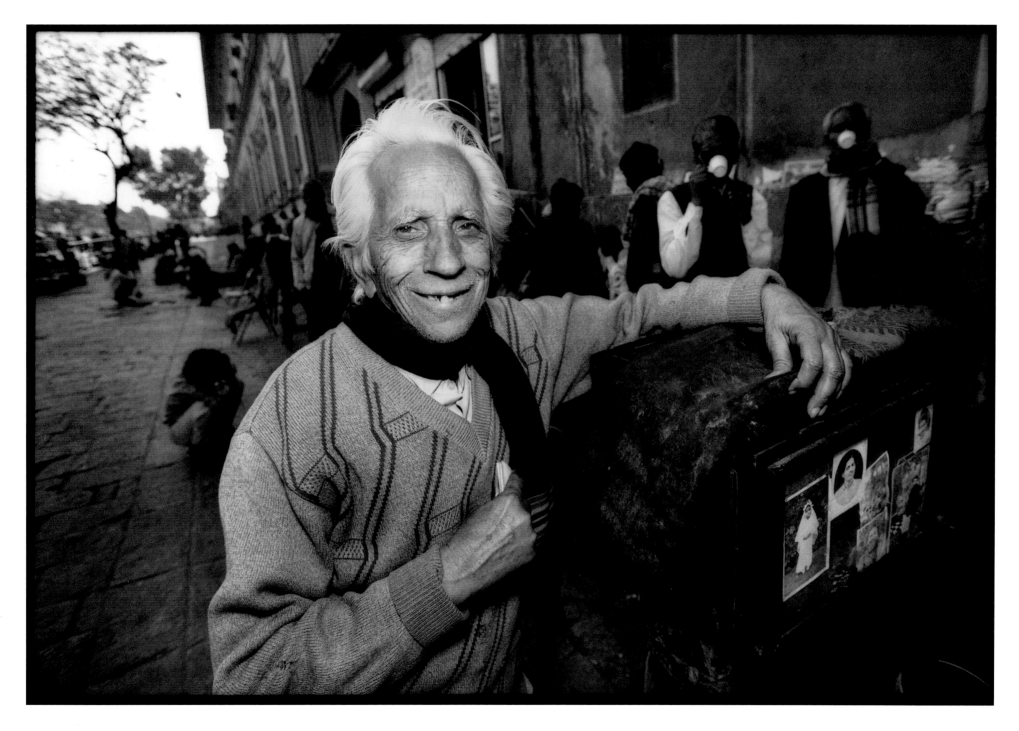

Street Photographer ∫ India 1998

Two of my favorite photographs from my 2010 book, *COUPLES: An Eclectic View*. Both were taken in cities that present challenges to photographers, particularly when it comes to photographing women, even as part of a couple. But if you spend enough time approaching compelling subjects without making any cultural missteps, and with a bit of luck, you'll be rewarded with images that reveal much about the societal situation they live in. And in one case here, we spent hours together, talking about our diverse backgrounds, our work, families, and so on, making that photograph all the more meaningful.

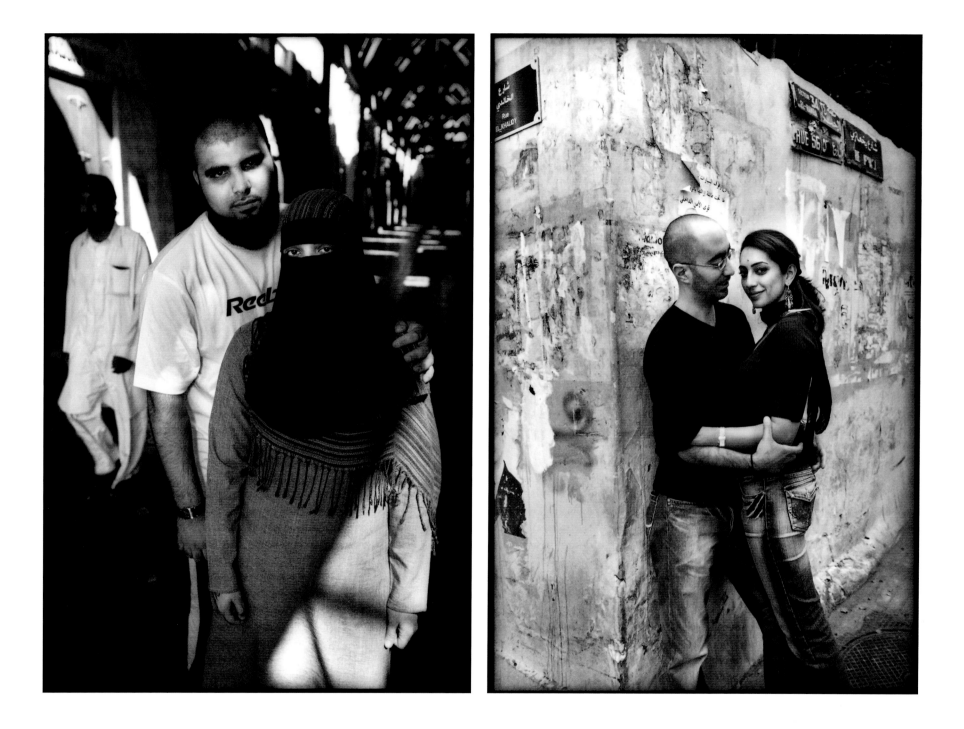

Couple in Dubai (left), Couple in Beirut (right) ∫ 2009

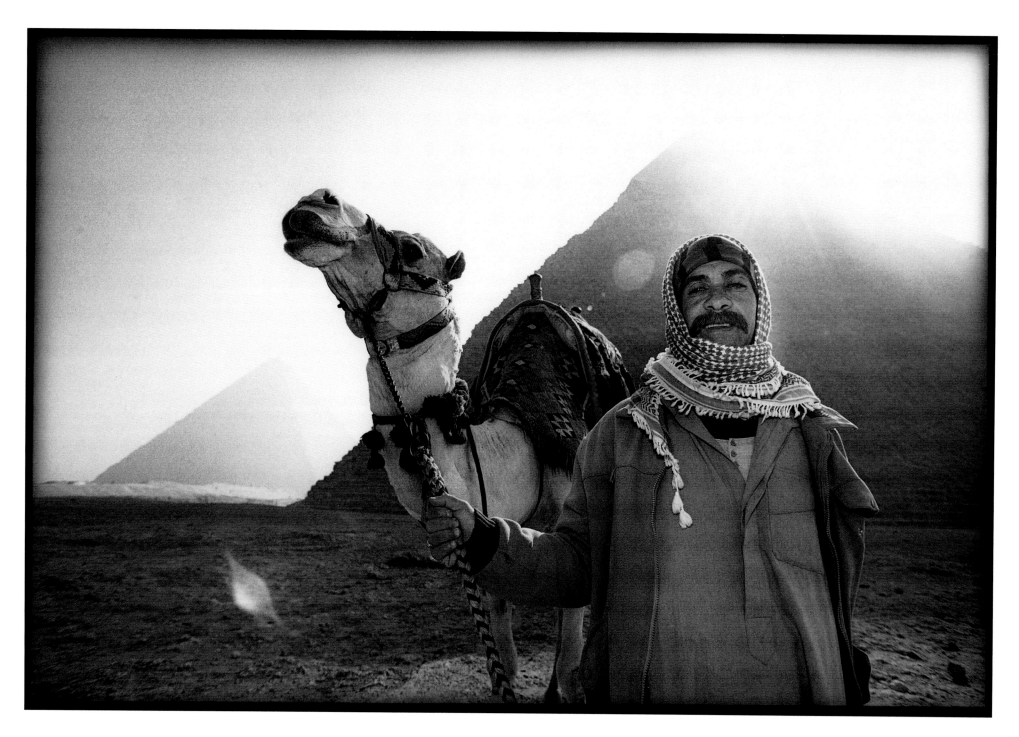

Sabre's Camel, Giza **ʃ** Egypt 1999

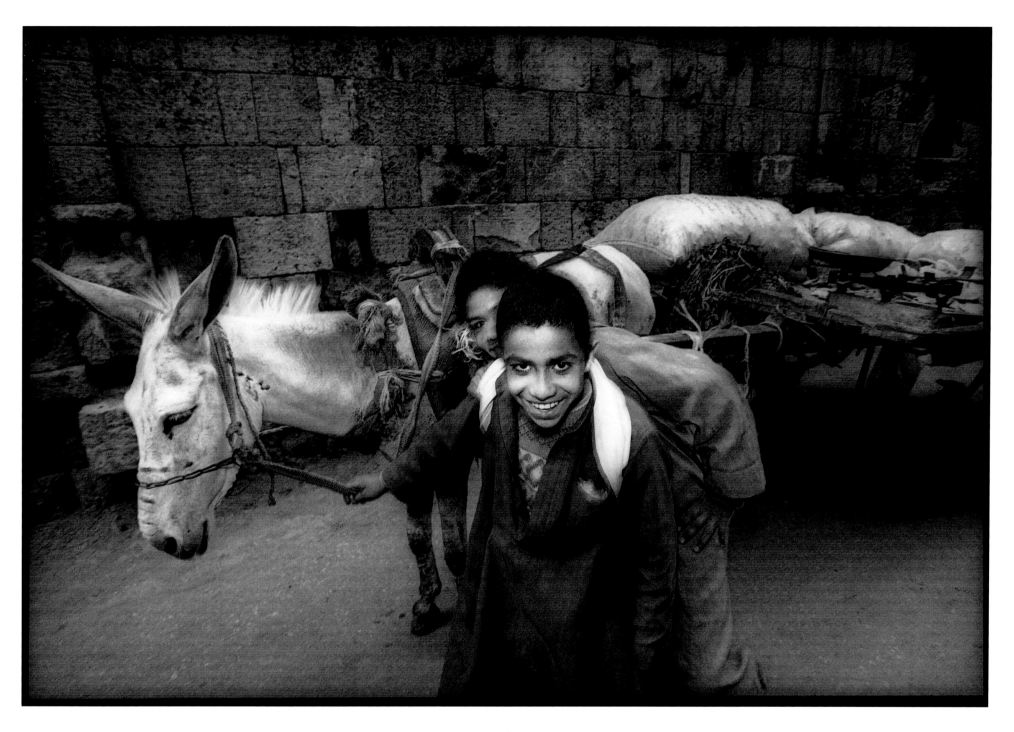

Boys in Cairo ſ Egypt 1999

This professor had witnessed decades of Irish history from his position at Trinity College in Dublin—you can see it in his eyes. The day I met him on the Trinity Quad, he was moving out of his book-filled office, retiring after years of teaching Ireland's best and brightest. He, however, was not the least bit enthused about being photographed, but after we talked for a while, and I'd carried a box or two, he decided I could be trusted with his image (I was Irish, after all!). I just wish he'd had more time to share a pint with me off campus.

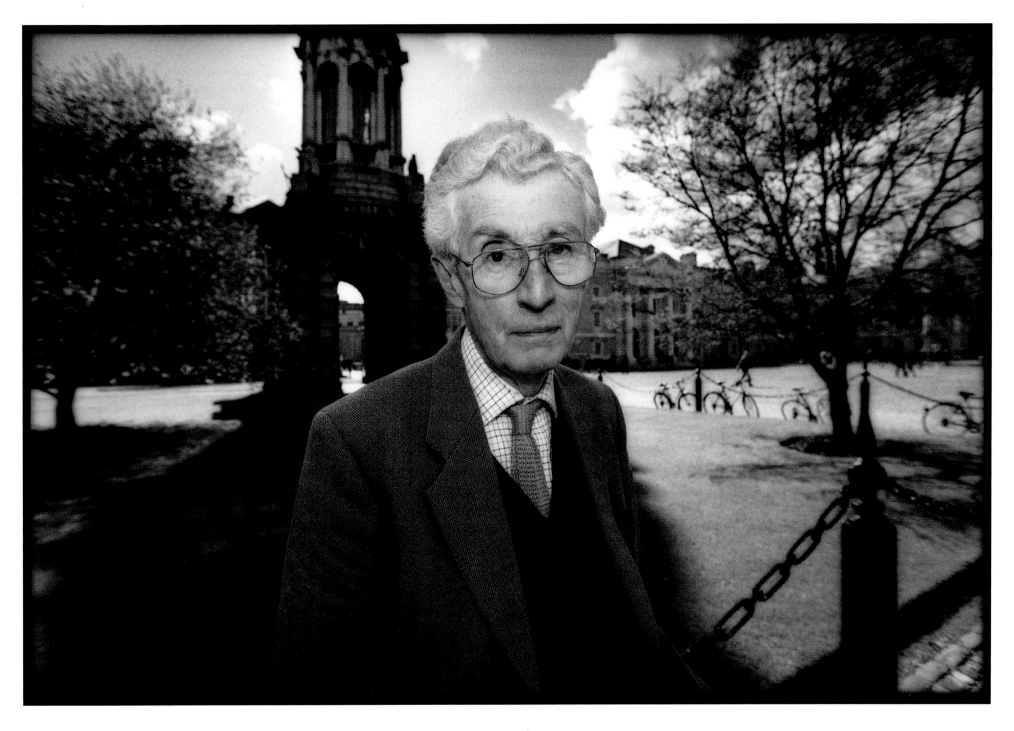

Trinity College Professor ∫ Ireland 1997

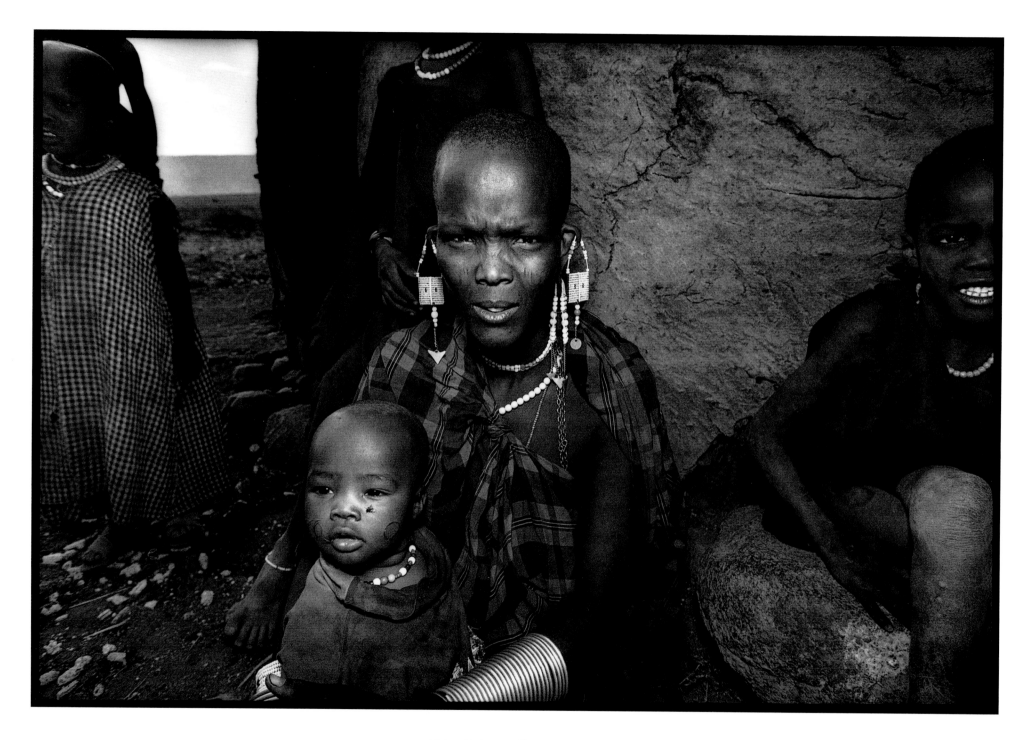

Mother with Children ∫ Tanzania 2001

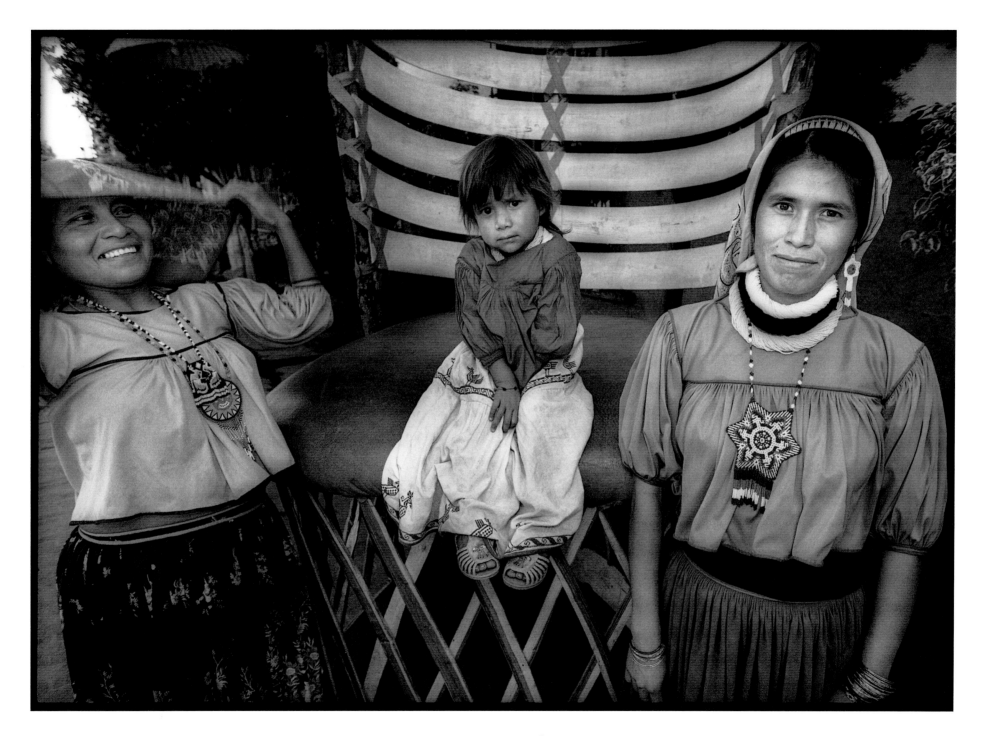

Girl on Chair, Tlaquepaque ∫ Mexico 1999

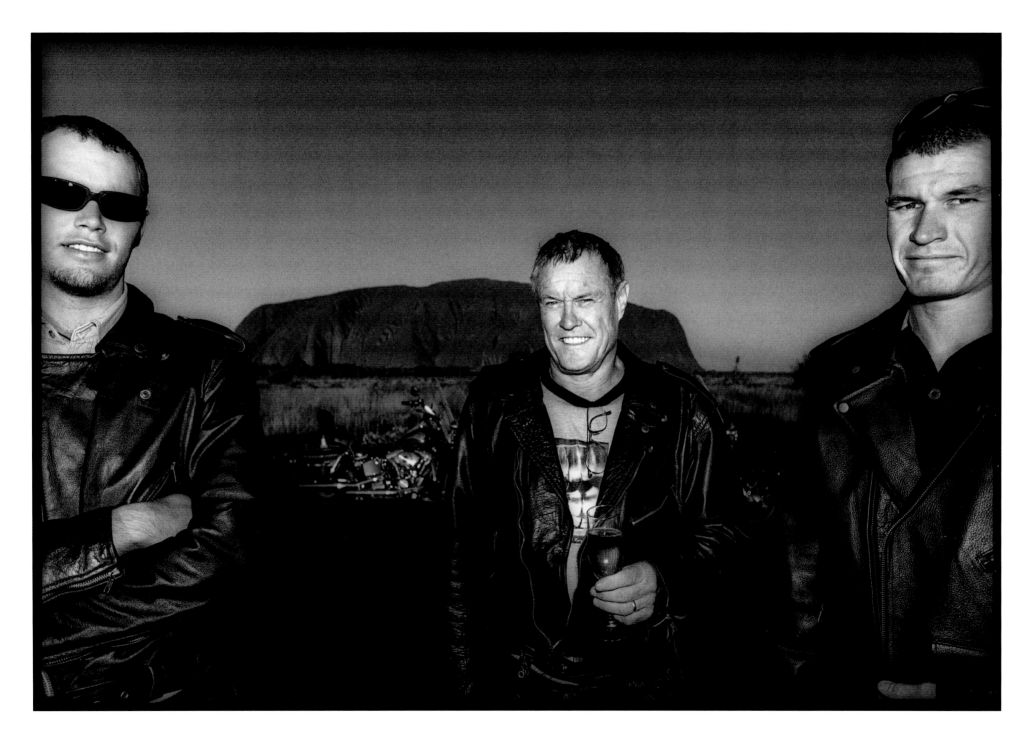

Ayers Rock Sunset ∫ Australia 2002

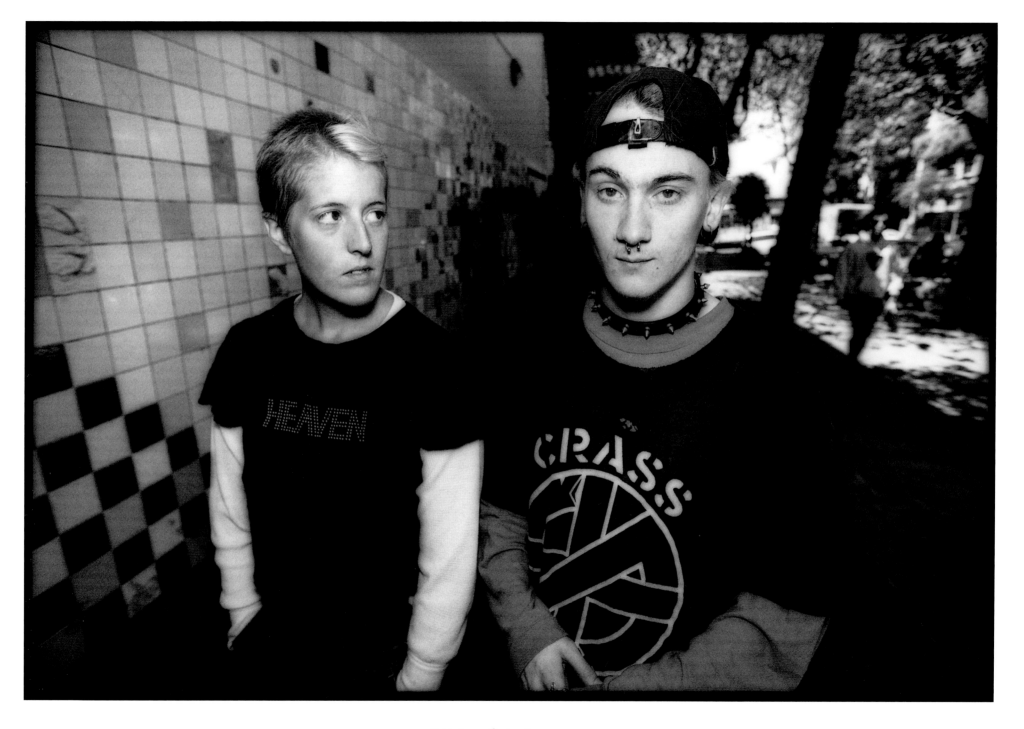

Haight Street ∫ San Francisco 1998

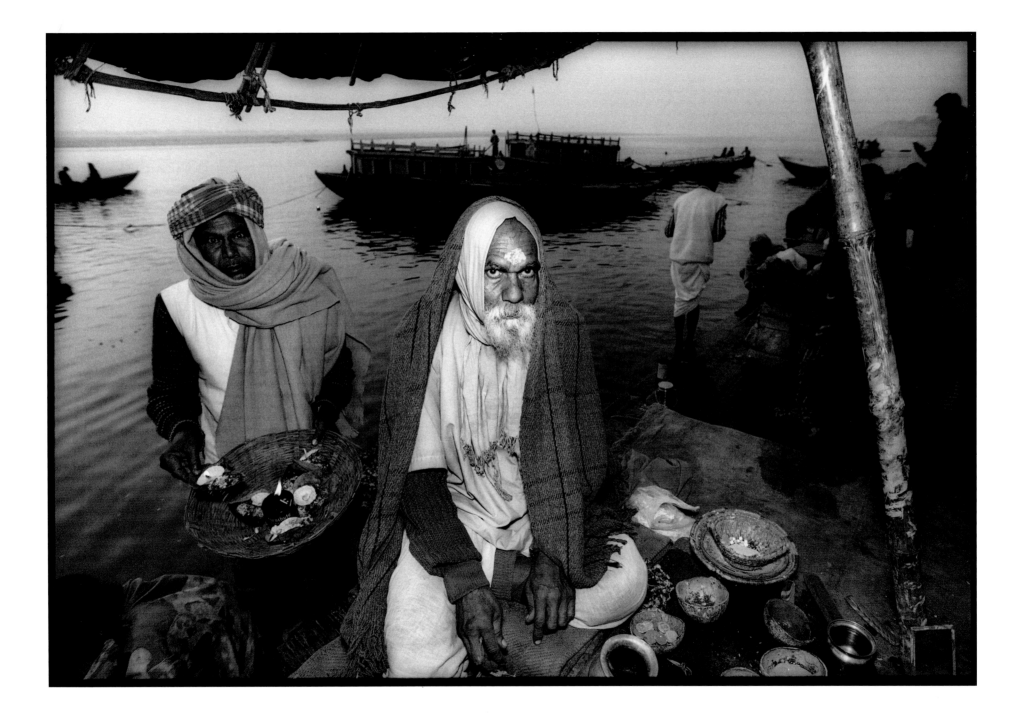

Dashashwamedh Ghat, Varanasi ∫ India 1998

"Photography can be a powerful connector."

I've experienced many instances of traveling on my own or with friends and students where asking permission to photograph and then showing the just-taken digital image to the person has created a connection—sometimes fleeting, at other times longer lasting. When language is a barrier, sharing the experience of the photograph and the encounter may be the only way to communicate. At the same time, this act of taking someone's photograph has always made me a bit uncomfortable, reminding me of images in old *National Geographic* magazines of Westerners dazzling "others" with their technology—whether a mirror, a phonograph, or a camera. And how much does this "connection" depend on inequality, on being in places where access to cameras or smart-phones is still limited or where people cannot afford them?

Sharon Gmelch ∫ *Cultural Anthropologist*

Holding a photographic print can be a moving experience

Many say that a photograph isn't real until it's in print form: 11×14, white border, reflecting light off its delicate surface. I agree. Digital is so ephemeral. A fine photographic print has a permanency to it, an object that you can hold, that isolates the subject it depicts within its borders and recalls the situation in which it was made. I know when I stop to look at prints on my walls, I'm brought back to that time, that 1/125 of a second, when there was a connection with the subject that made a deep impression on me, which often grows over time. And when I look at the prints of other photographers (say, the one of Nixon confronting Khrushchev in Moscow by Elliott Erwitt that hangs over my desk), or as reproduced in books, I'm drawn into their world and what they likely experienced the moment the shutter opened and closed.

A beautiful print is an object that can be appreciated over the years, can be passed on, may grow in value, and says much about the person who created it. The tactile, tangible experience of holding a photographic print can be a moving experience—the image is now a real photograph, not an ephemeral digital image floating on a computer screen.

And what better way to share that reverential experience than reproducing that image in book form, using the latest printing techniques to produce an object that, like the print, can be appreciated by a great number of people, and perhaps interest them in taking a more engaged role in the medium once they've actually studied the photographs. Maybe even interest them in buying an original print?

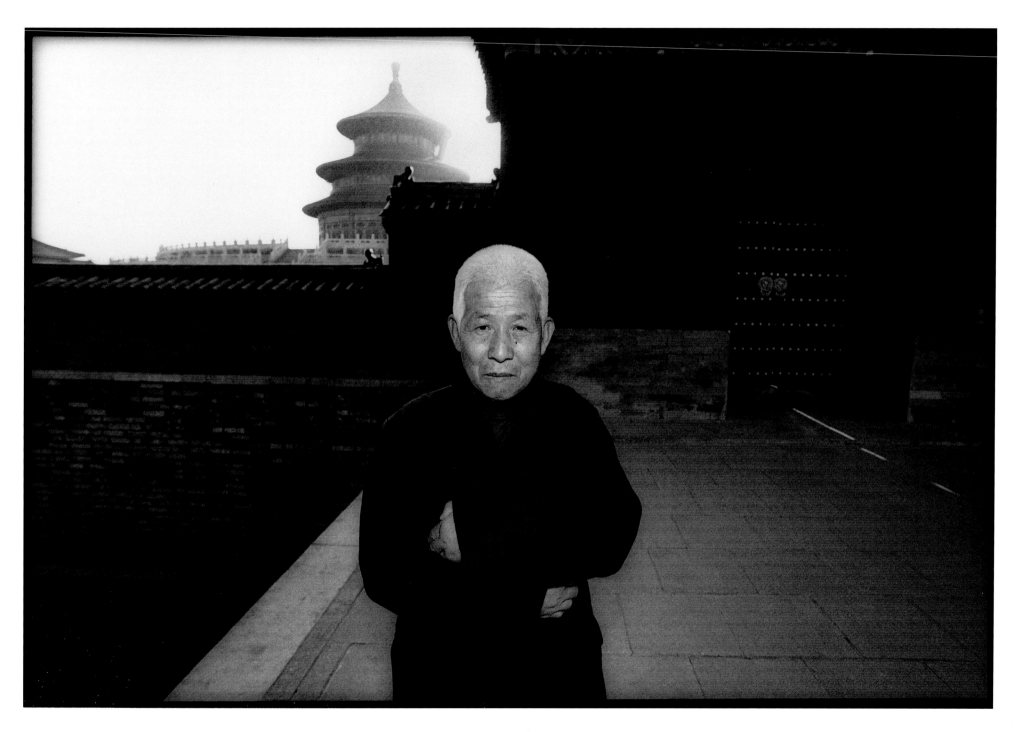

Tiantan Park, Beijing ʃ China 2000

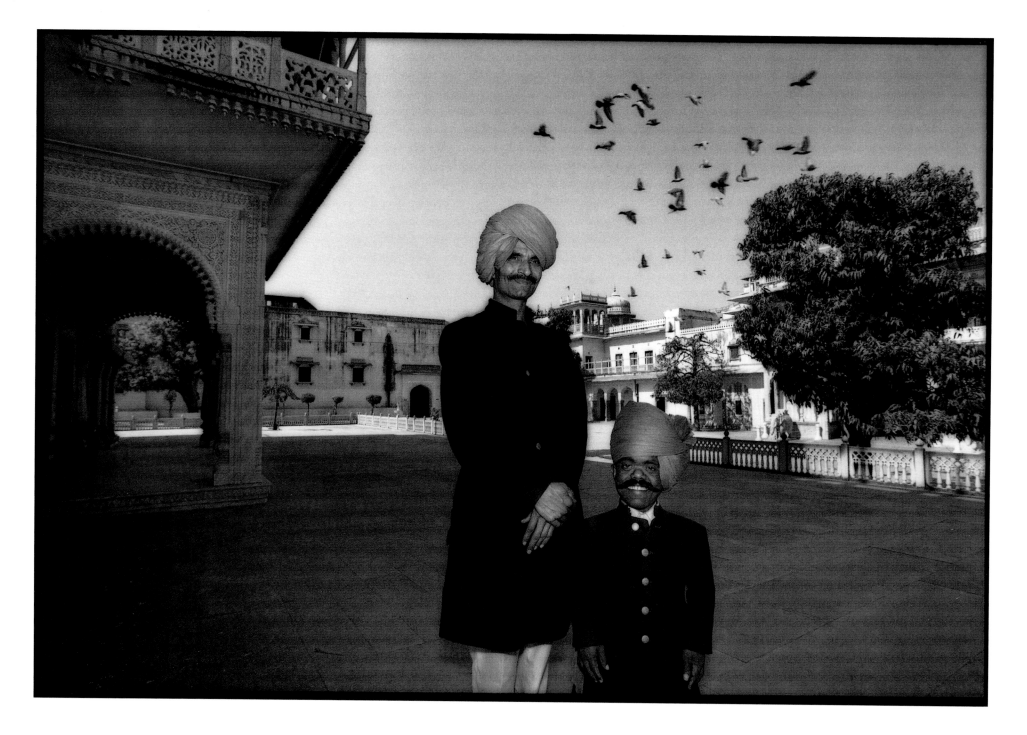

Jaipur Palace Guards ∫ India 1998